BRADFORD
IN
50
BUILDINGS

GEORGE SHEERAN

AMBERLEY

First published 2017

Amberley Publishing, The Hill, Stroud
Gloucestershire GL5 4EP

www.amberley-books.com

British Library Cataloguing in Publication Data.
A catalogue record for this book is available from the British Library.

ISBN 978 1 4456 6848 2 (print)
ISBN 978 1 4456 6849 9 (ebook)

Origination by Amberley Publishing.
Printed in Great Britain.

Contents

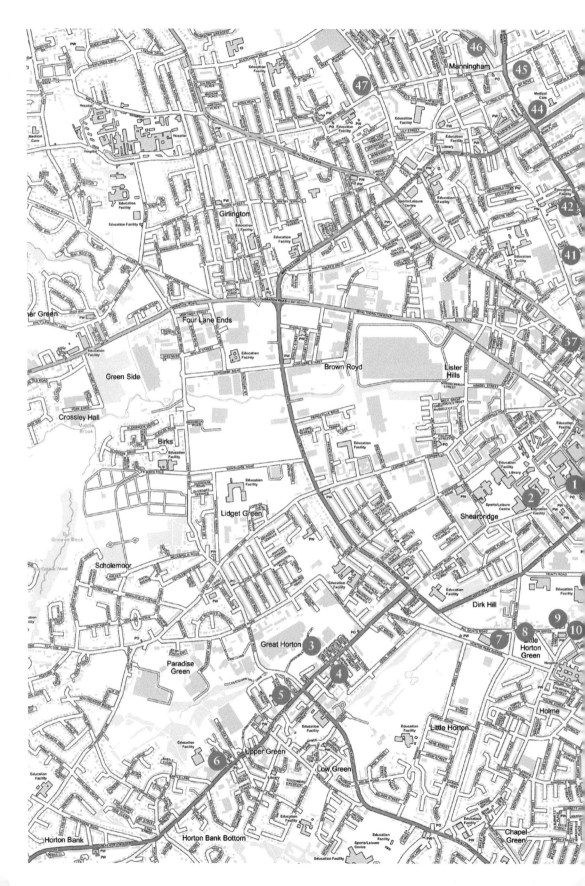

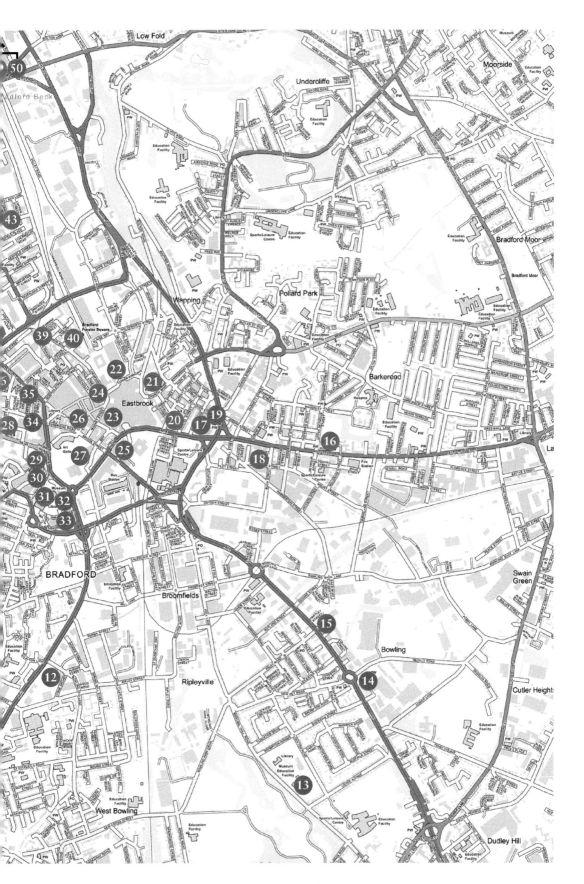

Key

1. Bradford College, Great Horton Road
2. University of Bradford, Richmond Road
3. Cannon Mill, Great Horton Road
4. Gathorne Street, Great Horton
5. Great Horton Methodist Church, Great Horton Road
6. Cottages, Dracup Street
7. Suffa-tul-Islam Grand Mosque, Horton Park Avenue
8. Cotton Weavers' Cottages, Little Horton Green
9. Little Horton Hall, Little Horton Green
10. All Saints' Church, Little Horton Green
11. Dixon's Trinity Academy, Trinity Road
12. Mitchell Brothers, Bowling Old Lane
13. Bolling Hall, Bowling Hall Road
14. St John's Church, Bowling, Wakefield Road
15. Former Police Office, Wakefield Road
16. Shree Laksmi Narayan Mandir, Leeds Road
17. Gatehaus, Leeds Road
18. Feversham Street School
19. Sion Jubilee Baptist Chapel, Peckover Street
20. Little Germany, Law Russell/Thornton Homan, Vicar Lane
21. Bradford Cathedral, Stott Hill
22. Midland Hotel, Cheapside/Forster Square
23. Wool Exchange, Market Street
24. Shoulder of Mutton, Kirkgate
25. St George's Hall, Hall Ings
26. Prudential Assurance Company Building, Sunbridge Road
27. City Hall, Centenary Square
28. Providence and Thompson's Mills, Thornton Road
29. Odeon Cinema, Prince's Way
30. Alhambra Theatre, Prince's Way
31. National Science and Media Museum, Prince's Way
32. Margaret McMillan Tower, Prince's Way
33. GPO Telephone Exchange, Manchester Road
34. Sunwin House, Sunbridge Road

35. High Point, Westgate
36. Council flats, Longlands district
37. St Patrick's Church, Sedgefield Terrace
38. Jamiyat Tabligh-ul-Islam Central Mosque, Westgate
39. Yorkshire Penny Bank, Manor Row
40. Warehousing, Manor Row
41. Bradford Reform Synagogue, Bowland Street
42. Belle Vue School, Manningham Lane
43. Tawakkulia Jamia Masjid, Cornwall Road
44. Bolton Royd House, Manningham Lane
45. Mount Royd, Parkfield Road
46. Cartwright Hall Art Gallery, Lister Park
47. Manningham Mills, Heaton Road
48. Saltaire Mills, Victoria Road, Saltaire
49. George Street, Saltaire
50. Congregational Church, Victoria Road, Saltaire

Introduction

To write about Bradford is to write about a city that stands amid the foothills of the Pennines. Before the mid-nineteenth century it was a small town with a parish church, while around it were satellite villages or 'out-townships': Manningham to the north, Great and Little Horton to the south-west, and Bowling to the south-east. But industrialisation and population growth in the nineteenth century resulted in the whole of this area becoming one mass of buildings thoroughly connected by suburbs, roads, railways, industry and housing with the old town of Bradford at the centre. In 1832, this area became a parliamentary borough; in 1847 a municipal borough; and in 1897 a city. In 1974, it became a metropolitan district, absorbing several other parts of the region.

The present-day centre of Bradford occupies the site of the old town that lies at the bottom of a bowl of hills and Pennine moorland, its former out-townships standing above it. Until the nineteenth century, the economy of this area relied heavily on an agriculture of small mixed farms. Oats were a staple of the local diet and herds of cattle for beef and dairy were also common. As the city of Industrial Revolution began to take shape, outlying farms found a ready market for these products. Industry was already present in the form of mineral extraction: coal and stone, carboniferous sandstones, and gritstones from the surrounding quarries.

But the industry most associated with Bradford is the woollen industry. One or two misapprehensions, however, need to be cleared up. Firstly, although wool textiles were made throughout the Bradford district, before the beginning of the nineteenth century the town itself was more a place of marketing than production. Secondly, while woollens were produced, worsteds were also common. While both are wool textiles, worsted is made of a combed woollen yarn that gives a fine finish.

By the mid-eighteenth century the Bradford district could be said to have an economy that was both partly agricultural and partly industrial, together with a textile industry that was domestically based. That being said, Bradford was probably something of a rough-and-ready place, possessing none of the poise or commercial success of neighbouring towns such as Leeds or Wakefield. This was to change. The first indications came late in the eighteenth century as a number of ironworks were established, especially at Bowling (1780s) and Low Moor (1791). By the mid-nineteenth century, output had become enormous – ordnance, railway castings, boiler plate and many other heavy engineering products. This iron industry and the engineering industries associated with it are sometimes overlooked, but were a key part of Bradford's success.

As industrialisation took hold of the area, domestic textile production began to change as new technology was introduced. Spinning mills were already appearing from the 1790s, even within what we would regard as the city centre today. While woollens and worsteds were the focus of manufacture, by the 1820s a new form of textile was being trialled. This was Orleans, a type of worsted composed of cotton warps and woollen wefts.

The importance of this cannot be overemphasised, since it was the foundation of Bradford's textile fortunes. Mohair and alpaca were to be to be added to this mix to produce what became a fashion fabric, with Bradford becoming famed for its Orleans. From the 1840s, the industrial scale of operations rose: combing works, spinning mills, manufacturing mills; the arrival of the railways; the construction of bold new warehouses for home and export wares – all produced a boom-town economy.

But there was a human cost. Huge industrial development needs labour and, as such, Bradford's population soared from 13,264 in 1801 to 103,771 in 1851. The Pennine town had grown rapidly into an industrial giant, a morass of factories, insanitary houses, churches, chapels and a dram shop around every corner. Rioting in 1848 led the newly formed municipal corporation to examine the moral condition of the town. The findings shocked the Victorian civic elite. From the 1850s increased building controls were imposed and much of central Bradford began to be rebuilt. Between 1850 and 1880 many of the Victorian buildings we associate with the city came into being, and by the end of the century Bradford had become the most important centre of yarn and worsted production in Europe. Its warehouses exported goods across the world and it had established a trading floor for futures in wool and fibres at the Wool Exchange. In 1901, the population stood at 279,767, an increase that placed Bradford among the top ten largest cities in England and Wales. So thorough was this reordering of Bradford's social and physical fabric that, as one Bradford historian put it, 'anyone revisiting Bradford after an absence of a quarter of a century or so, would fail to recognise it'. (William Scruton, *Pen and Pencil Picture of Old Bradford*, 1889)

The development of Bradford in the twentieth century is one of boom and bust, massive new housing developments and clearances, and of the textile industry's long decline. The industry was badly hit in the Great Depression, yet it was to make a comeback in the years immediately following the Second World War. The effects of war and a reconstruction of the industry led to recruitment for labour in Europe and the Commonwealth, although migrants came mostly from two countries: a relatively small number of Italians, mostly women, who became resident, and much larger numbers of people from South Asia. Unlike migration from Italy and other parts of Europe, which decreased in the 1960s, migration from South Asia – largely from Pakistan – persisted and has continued to grow. The census of 2011 shows that South Asian Muslims made up 24.7 per cent of the metropolitan district's population, and, in some inner-city wards, 30–50 per cent. After 2000, this diversity increased owing to further migration from Europe, mostly from Poland and Romania.

Much of this movement took place at a time of optimism. Optimism was high in the post-war years, as parts of central Bradford were dismantled to be replaced by the radiant vision of tower-block modernists. But despondency followed as the textile and engineering industries collapsed in the late 1970s and '80s and the shops put up 'To Let' notices. Today, the watchword is 'regeneration'; regeneration of what, in places, remains a bleak landscape of derelict works and mills. But the city does continue to develop as some Victorian warehouses and mills have become smart offices or apartments, and the building stock has been further added to by both post- and neo-modernist structures.

Buildings are political. Some are proposed by local administrations, whereas some are devised to dominate public space. They are redolent of conflict and struggles, and they represent the civic qualities that many value. What follows in these pages takes us through some of the highs and lows of it all.

The 50 Buildings

1. Bradford College, Great Horton Road

It is surprising that in a town such as nineteenth-century Bradford, technical education took such a long time to be given shape in the form of a college. In 1832, the Mechanics Institute was formed, although this was intended for the broader education of adults generally. Then in the 1850s a college for education in art, design and technology was proposed, although it was nearly thirty years before any such scheme came to a final result. The Bradford Technical School, as it was first known, was built on a site in Great Horton Road and opened in 1883. This new technical school was designed by Hope & Jardine and won great praise in its day – the *London Magazine* described it as 'a building on a scale of completeness, which will throw into the shade any previous attempts made in this direction in the country'. Magnificent classical building though it is, with a stunning entrance (a giant

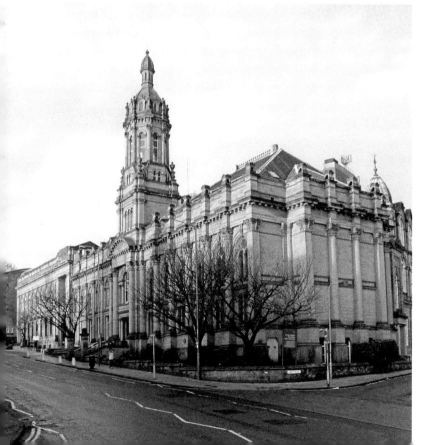

Bradford College,
Old Building, 1883.

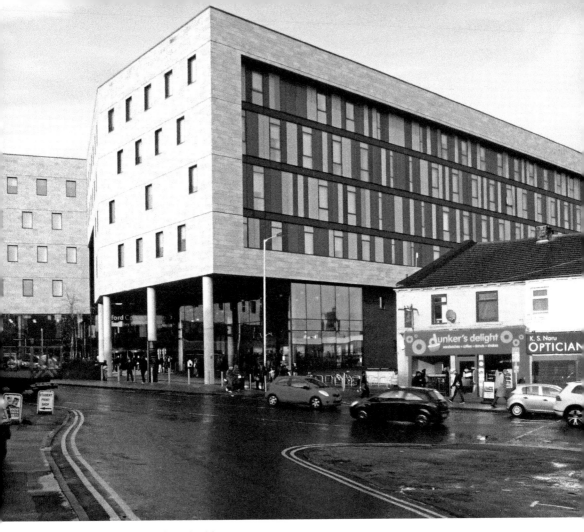

Bradford College, Hockney building.

door frame surmounted by a baroque tower), yet few other than Pevsner (*The Buildings of England: West Yorkshire*) have asked why the range to the right of the entrance has columns along its exterior, while that to the left has pilasters. It is very odd.

In the 1960s, the college expanded to accommodate increased provision. Completed in 1966, this new building became Bradford Technical College, and while its design was typical of 1960s modernism – plate glass forming much of the frontage – it lacked imagination, other than in its portico, a gabled sheet of concrete that was cantilevered above the entrance. This building has been removed over the past three years and new college buildings have taken its place. These present a bland, if monumental, aspect to Great Horton Road, but give something of a bookstack appearance along Randall Well Street and looking into the city centre. These new buildings have a more distinctive and somewhat more dignified appearance than their predecessors of fifty years ago. It is also worth recording that art and design played a leading role in the nineteenth-century college, and has continued to do so. As the Bradford Regional College of Art, its most famous student was David Hockney, who studied there between approximately 1953 and 1957. Part of the new buildings on campus have been named after him.

2. The University Of Bradford, Richmond Road

A question sometimes raised is why, in contrast to cities like Leeds or Manchester, was there no move towards the creation of a university in nineteenth-century Bradford? It is a difficult question, but the answer is probably connected with the prioritising of primary education. One of Bradford's MPs, W. E. Forster, piloted the Bill through Parliament that, in 1870, became the Elementary Education Act. Emphasis was placed on technical education in the late nineteenth and twentieth centuries, and in the post-war years, in addition to the rebuilding of Bradford Technical College, a College of Advanced Technology (CAT) was planned for an adjacent site in 1957. The new CAT was housed in the Richmond Building, a glass-fronted block, faced with sawn gritstone, and with a principal lecture theatre projected over the main entrance in the manner of a porte cochère. The CAT had less than a decade in its existence as such, for it was to become a university in 1966 under the post-Robbins expansion of higher education. Further buildings were added across the campus

University of Bradford, Richmond Building.

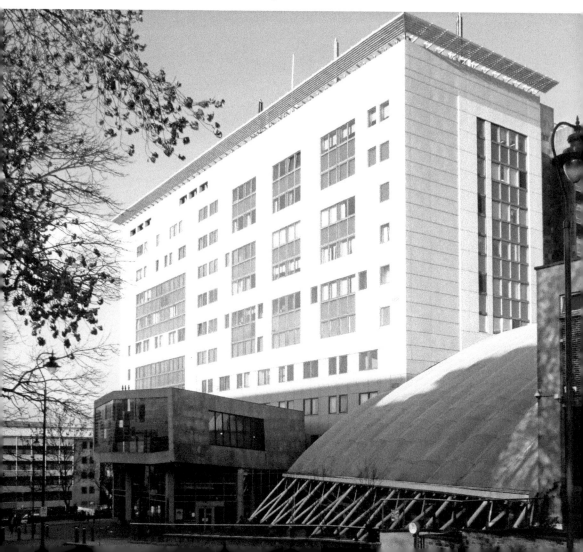

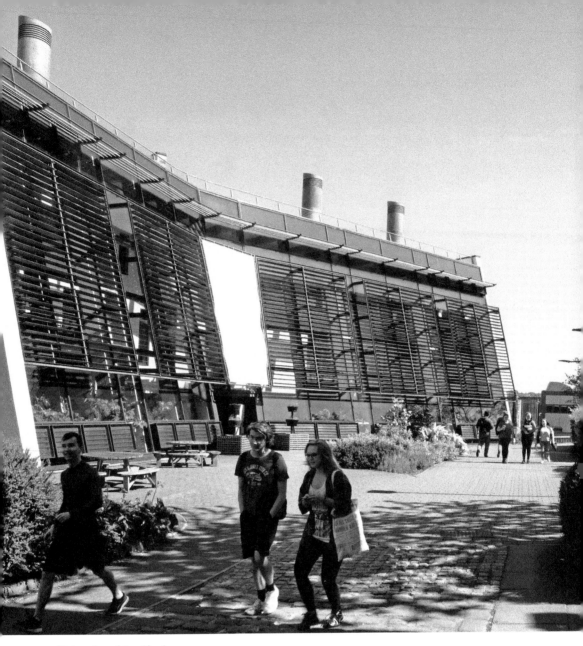

University of Bradford, re:centre.

from the late 1960s and into the 1980s, the Richmond, Chesham and Horton buildings taking their names from the former streets on which they stood.

From the beginning of the twenty-first century, ecological concerns have driven campus development with an emphasis on recycling and energy efficiency, hence the recladding of the Richmond Building. Other new buildings, such as the 're:centre', have attained high levels of insulation through the use of natural materials such as hemp in their construction, as well as using photovoltaic energy and air-source heat pumps. Perhaps unsurprisingly, the university has been highly commended for its sustainable building programme of recent years. This has been combined with some style also as in the north elevation of the re:centre, which provides a cool, sleek appearance on this side.

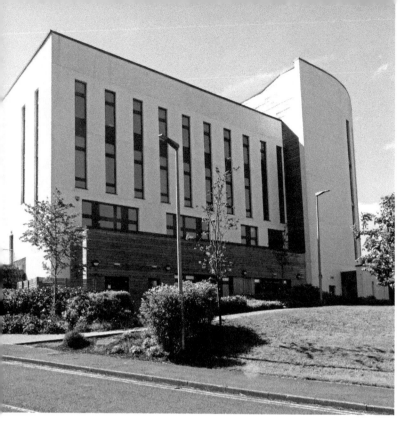

re:centre North Side.

3. Cannon Mill, Great Horton Road

The Victorian industrialist is often portrayed as an autocrat, a little prince in his mill-owning fiefdom. Not all mills, however, operated like that. Some were tenanted or in multiple occupation, though externally they might give the appearance of the archetypal textile mill. Cannon Mill in Great Horton operated in this way, on what was known as a 'room and power' basis. This allowed space to be rented together with the power to drive machinery. A business might be in production on its own account or on commission; it also allowed larger manufacturers to expand capacity by renting room when markets demanded. Although in a dilapidated state today, it is a rare example that can be confidently described as a room and power mill, and is typical of many former Bradford textile mills.

Cannon Mill was originally built in 1826 by Samuel Cannan of Great Horton, but a chimney collapse in 1839 led to closure and the eventual acquisition of the site by Charles Tetley, a member of a family of textile merchants with interests in other businesses as well. The mill was to be rebuilt around 1850–55 and renamed. In the landscape illustration, the weaving department was in the low sheds to the left, while the storeyed buildings provided spinning and warehousing. What is missing from the site now is the mill chimney, which was taken down some years ago after the mill had ceased production. What does remain is some of the Italianate detailing to the mill's yard entrance, probably by the architects Andrews and Delauney whom Tetley had commissioned for the rebuilding.

Adjacent to the mill is a series of small streets of houses. The owners of mills often had houses built nearby to ensure a supply of labour on their doorsteps. These houses, however, were part of a scheme carried out by the Tetleys in the 1860s to demonstrate that decent

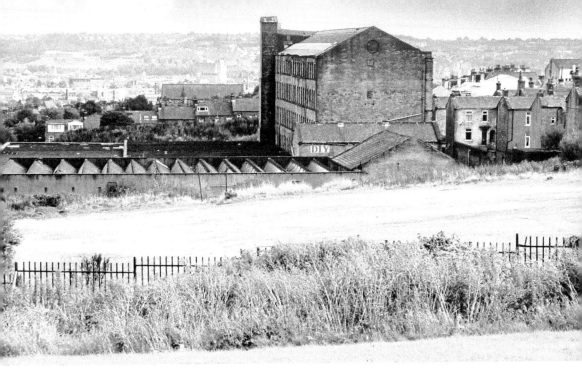

Above: Cannon Mill.

Right: Mill Yard
entrance, 1850s.

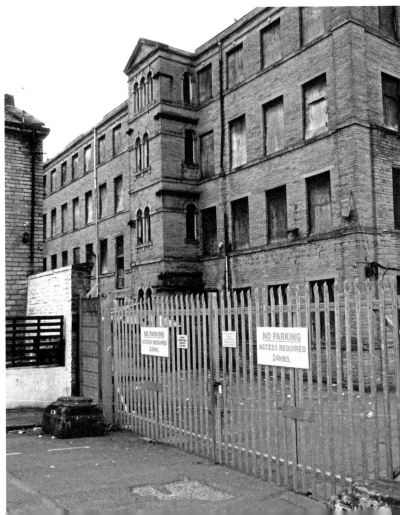

Street leading to Cannon Mill, 1860s.

houses, soundly constructed and with good sanitation, could be built for the working class, in contrast to much of the insanitary housing that had been built in the previous thirty years around Bradford. If not planned with workers at Cannon Mill in mind, many textile workers lived there, nevertheless, and such sites demonstrate that industrial buildings often need to be seen in their cultural environment.

4. Gathorne Street, Great Horton

The rising populations of nineteenth-century industrial towns put pressure on the supply of houses, especially for working-class residences. One mass-housing form this gave rise to was the back-to-back cottage – usually terraced. These houses were frequently built with one cottage fronting the street and another built behind, sharing a back wall but with no intercommunication. The reason for building in this way was not so much economies of building materials and labour – which there were – but the greater numbers of houses that could be built on a given plot, and hence a greater number of rents.

Back-to-backs became a predominant mass-housing form in nineteenth-century Bradford. They were universally condemned by housing reformers as being unhealthy due to there being no 'through ventilation', to use the terminology of the day. Those who built them did not agree. There was no problem with the form as such, but many were poorly

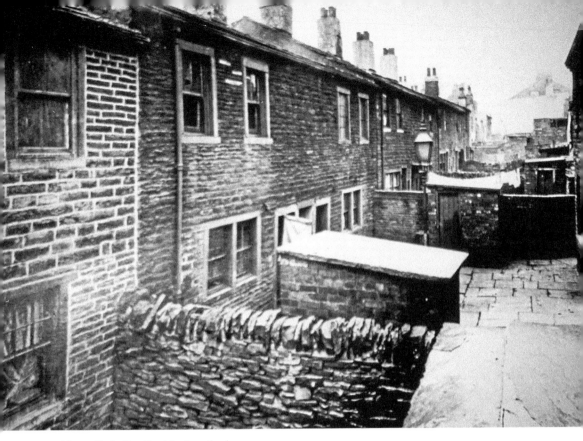

Above: Early Bradford back-to-backs.

Below: Gathorne Street, 1872–73.

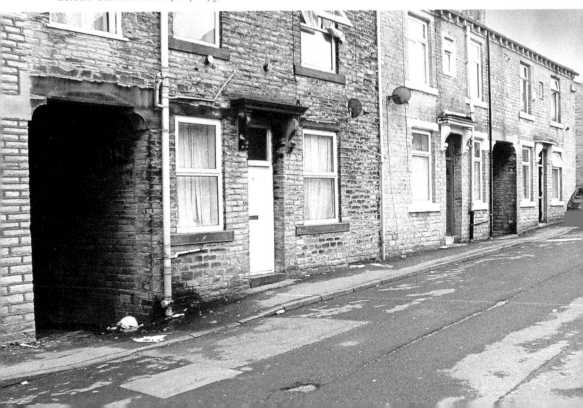

built, overcrowded and had inadequate sanitation – as in the monochrome photograph from around 1915 of back-to-backs built in Bradford *c.* 1830. Housing and sanitary reform were a priority for Bradford Corporation, whose officers were to introduce new building regulations in 1860 that effectively put an end to the building of back-to-backs. The public outcry from speculators and others was so strong, however, that new bye-laws were introduced. After 1865 the building of back-to-backs resumed but they were subject to stringent regulation, which included minimum street widths, one privy to every house, and wide passageways between each pair of houses.

These houses in Gathorne Street, Great Horton, illustrate the new pattern of Bradford back-to-backs after the middle of the century. This street was developed piecemeal partly by a Bradford butcher named William Casson in 1872 and 1873. Their otherwise workaday fronts are relieved by a canopy on shaped brackets above their front doors, and dentillated courses at the eaves. But notice the large opening to a passageway between the houses. In conformity with the new regulations, this gave access to a rear yard where the lavatories and ash pits were located. These needed to be emptied periodically, hence the wide passageway for access and ventilation. 'Tunnel backs', as they were termed, became a highly distinctive feature of Bradford's housing provision in the second half of the nineteenth century. Such houses continued to be built, providing homes for thousands of working-class families until the back-to-back was banned altogether by the Housing, Town Planning, &c. Act of 1909.

5. Great Horton Methodist Church

During the nineteenth century, evangelising elements within the Church of England attempted to restore Anglican influence through ambitious schemes of church-building. Nonconformist denominations were similarly keen to extend their faith through building, and at times it seems as if there were a competition to decide who could outbuild whom. Such religious ambition with regard to building is plain to see in a town like Bradford. Whereas in the past nonconformity had often been associated with the lower ranks of society, with plain dress and simple chapels, the position was changing in the nineteenth century as a rising middle class was growing in wealth and confidence. As Edward Parsons of Leeds had commented of the Methodists in 1834 in his *Miscellaneous History of Leeds*, 'now their places of worship, in many instances, are truly splendid edifices', and their dress and habits had similarly become more sophisticated. Nonconformity was also becoming a challenge to the Church of England throughout the industrial towns of the north. In Bradford, for example, the 1851 religious census showed Wesleyan Methodist church attendance to be only slightly behind that of the Church of England, while Methodists as a whole (for example, New Connexion and Primitive Methodism) far exceeded attendance at Anglican churches – 16,637 to the Church of England's 10,155.

In order to meet this demand, new churches and chapels were built. The Wesleyan Methodists of Great Horton had built a school and chapel there in 1814, but by the mid-nineteenth century this had become too small. A new chapel was built to the designs of the Bradford architect Samuel Jackson in 1861–62. The entrance front faces Great Horton Road and is a typical piece of Italianate design of the mid-nineteenth century, and yet it is striking how the influence of a Renaissance architect such as Andrea Palladio can still be felt in its proportions and the employment of a temple front. It does not require too

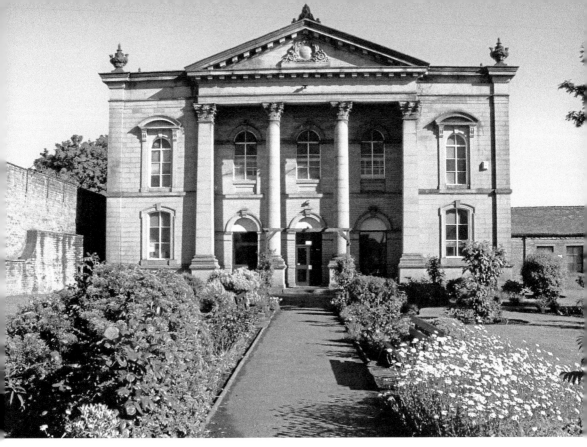

Great Horton Methodist Church, 1861–62.

great a stretch of the imagination to see this as the entrance front of a sixteenth-century villa situated in the Veneto. A number of Palladio's villa designs might have supplied the model, with suitable modifications to the window openings to admit greater light in the dull atmosphere of industrial Bradford.

The chapel seems to have been completed towards the end of 1862 since an advertisement in the *Bradford Observer* for 11 December gave details of opening sermons in the same month, with an opening service on New Year's Day 1863, to be concluded with a 'Public Tea Meeting'.

6. Cottages, Dracup Street, Great Horton

In some ways these cottages characterise Bradford's early nineteenth-century industrial development. These and others like them that have survived in the Great Horton district were built to house working families who gained their livings from a variety of occupations, although the textile industry provided work for the majority. In Great Horton, people were as likely to have worked in the cotton industry as in the wool textile industry. Cotton spinning and calico weaving were common here, and products were marketed in Manchester. The industry declined greatly, however, after the middle of the century when the Manchester merchant house of Butterworth and Brooke failed in 1845, taking many of the cotton masters and weavers with them.

Cottages, Dracup Street, before 1840.

Early housing in this area is bound up with that industry and this pair is typical. They are low and regional in appearance, and have not yet made the transition from vernacular styles of building to nationally recognisable Victorian designs. Built before 1840, they are constructed of thin courses of local sandstone and have sandstone flag roof coverings. Their doorways and windows retain stone casings in the manner of a century earlier, some windows containing mullions. A departure from past traditions is that they are built back-to-back, as others around them were, although many back-to-backs of this date have been cleared away, and survivors tend to be a rarity. By the middle of the nineteenth century, cottages like these ceased to be built, as mass-housing to accommodate Bradford's ever-increasing population came under the strict controls mentioned previously.

7. Al-Jamia Suffa-tul-Islam Grand Mosque

The Bradford Metropolitan District has one of the largest Muslim populations in England and Wales expressed as a percentage of population. In 2011, it was 24.7 per cent of the metropolitan district, while in wards that make up the city it is much greater: in Little Horton, 57.96 per cent; Manningham, 74.97 per cent. People from South Asia came to Bradford for a number of reasons, but two factors were of prime importance in the post-war years. Firstly, the 1948 British Nationality Act – despite later amendments – smoothed the passage to Britain for people from Commonwealth countries. Secondly, the need to

rebuild industry after the Second World War led to a reconstruction of the local textile industry and a consequent need for labour. While migrants came to Bradford from across the Commonwealth, they were predominantly from Pakistan and predominantly Muslims.

It is hardly surprising, then, that a large number of mosques have been built in the city in recent years. The Al-Jamia Suffa-tul-Islam Grand Mosque is the largest and most elaborate of several large, purpose-built mosques in the city. The Suffa-Tul-Islam mosque was located on a city centre site in 1982, but proved too small to accommodate worshippers, and a new site near Little Horton Green was bought in 1998, with the foundation stone laid the following year. It is built of mostly red and buff sandstones imported from the Asian subcontinent, which perhaps forms a link with homelands. Its massing is huge and twin-domed, but seemingly anchored in position by the four minarets. Yet it also contains more delicate detailing, such as the medallions that run like a frieze above the windows or the impressive clusters of towers and the embellishment of the upper stages of the minarets.

At the time of writing it is almost complete, although it has been open for prayers for some time. If work seems to have progressed slowly, it should be realised that this is a large and elaborate mosque paid for to a large extent by the donations of its congregation. This and similar mosques have provided some of the more distinctive architecture in Bradford in recent years.

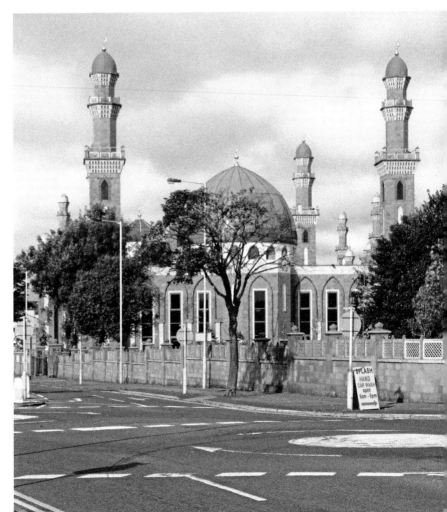

Suffa-tul-Islam
Grand Mosque,
1999 and later.

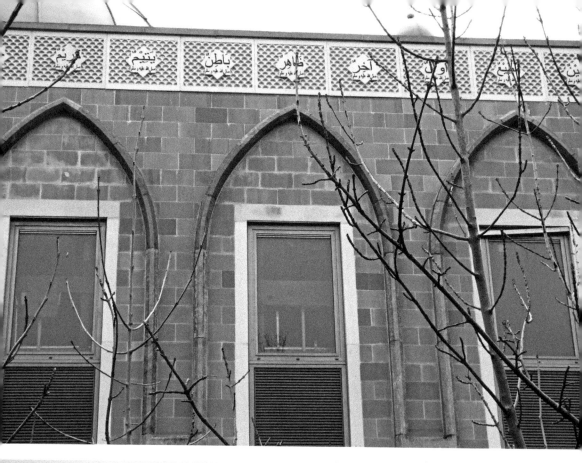

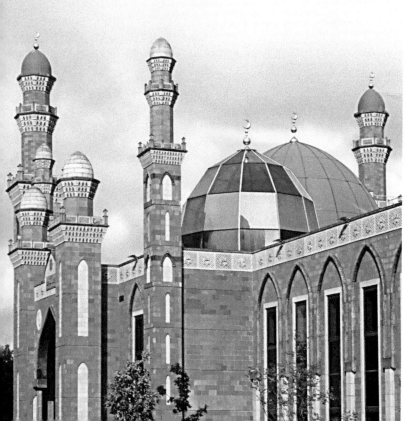

Above: Medallions
and windows,
Suffa-tul-Islam.

Left: Domes
and minarets,
Suffa-tul-Islam.

8. Cotton Weavers' Cottages, Little Horton Green

The importance of the cotton industry to the Horton area of Bradford has been mentioned earlier. This sturdy row of cottages at Little Horton Green is a testimonial to the viability of that industry. Constructed of sandstone, they have flat-faced mullions and surrounds to their windows with door frames of a similar design. The finish to the ends of the row with raised quoins (cornerstones) adds to the feeling of quality in what is otherwise a traditional building type. The feature that makes an immediate impact, besides the height, is the blocked openings above the nearest doorway. These were taking-in doors, where raw materials could be hoisted to a domestic workshop without the inconvenience of manoeuvring them through the house, and carts could be loaded directly from workshop to street. The presence of taking-in doors in the two upper storeys suggests that production took place over two floors with domestic accommodation being restricted perhaps to the ground floor, upper working space having better light.

Judging from the detail of this frontage, these cottages would seem to date from the late eighteenth century. Two- and three-storey textile workers' houses were common throughout the clothing districts of west Yorkshire. That these were the homes of cotton workers is alluded to by the nineteenth-century Bradford historian William Cudworth, who comments in *Rambles Round Horton* (1886) that they were built by Samuel Swaine who 'carried on the cotton trade', and that they were occupied by John Riley who 'made cotton pieces', that is, calico. As detailed earlier, the trade in calicoes was largely discontinued in Bradford after 1845.

Cotton weavers' cottages,
Little Horton Green.

9. Little Horton Hall, Little Horton Green

One of the remarkable things about Bradford is the way in which its urban growth in the nineteenth century often engulfed, yet preserved, earlier hamlets and out-townships. Little Horton Green is a good example of this. It consists of little more than a single street that runs past the former green of Little Horton. At its eastern end, Horton Hall and Horton Old Hall once stood. Both of these seventeenth-century houses were demolished some years ago, yet Little Horton Green today still presents one of the outstanding streets in Bradford, architecturally speaking. Along its length can be found examples of the architecture of all periods between the sixteenth and nineteenth centuries, from cottages to houses of the elite.

Little Horton Hall is a fair example of this. Ostensibly, it is a house of perhaps the mid-seventeenth century, with a gabled frontage and large and carefully balanced mullioned windows. However, parts of the timber frame of an earlier house (possibly from the late fifteenth or sixteenth century) have survived internally, the whole building having been remodelled and cased in stone. It is the design of the house that might have been built by minor gentry, professional families, merchants or wealthy yeoman farmers. What houses like this reveal about Bradford, besides a rich architectural heritage, is the way the rural origins of what we consider to be an industrial city are reflected.

Little Horton Hall.

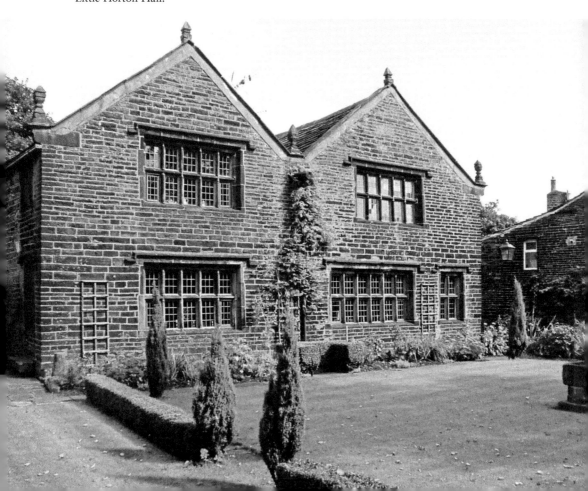

1c. All Saints, Little Horton Green

As discussed above in relation to Great Horton Methodist Church, northern towns such as Bradford were regarded by the Church of England as strongholds of nonconformity. It is not surprising then that there should be an upsurge of evangelical activity in an attempt to revitalise Anglicanism in the nineteenth century, especially given a greatly increasing population and the need for more places of worship. The solution to such problems took different forms, but one was the formation of local organisations dedicated to building more churches and thus meeting the challenges of population increase and nonconformity.

The Bradford Church Building Society was an Anglican society formed in 1859 with the aim of building ten new churches around the town. Of the churches that they built,

All Saints, Little Horton Green, 1863.

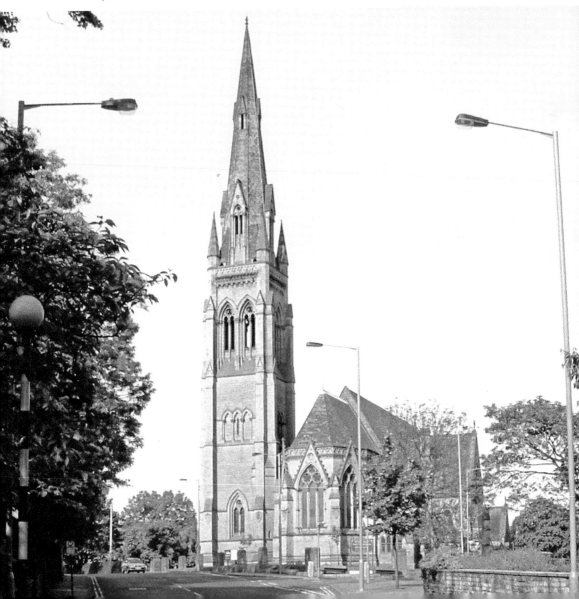

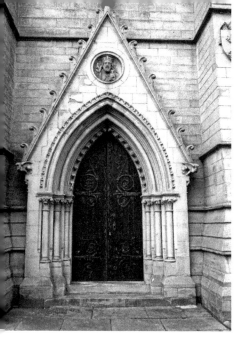

All Saints entrance.

All Saints in Little Horton Green is undoubtedly the finest. It stands at the east end of the Green almost opposite what was the workhouse (now St Luke's Hospital) on a piece of land given by Francis Sharp-Powell of Horton Hall, who also paid for the church and endowed it. It was completed in 1863 to the designs of Mallinson and Healey, a well-respected firm of ecclesiastical architects. They provided a design in a Decorated Gothic style with geometric tracery to the windows. The spire is set to one side of the church and it makes a magnificent impact both in its height and slim proportions, creating a landmark visible across several parts of the city. Yet this should not deflect the attention from the profusion of carved detail both internally and externally. This caught the imagination of the correspondent of *The Times*, who reported on the laying of the foundation stone in November 1861 that it was to cost £10,000, but 'costly ornamentation of an appropriate character … may increase the estimated expense considerably'.

The church remains open as a church, a continuing monument to the resolve of the society.

11. Dixon's Trinity Academy (The Unity Building), Trinity Road

The term postmodernism is one that encompasses a variety of meanings and nuances. When applied to architecture it means more than simply a style that came 'after the modern', but implies a way of building, which the commentator Charles Jencks in *What Is Post-Modernism* (1996) has described as 'double coding', that is 'the combination of modern techniques with something else (usually traditional building) in order for architecture to communicate with the public'. Bradford does not have a large number of postmodern buildings, but there are some impressive designs among the ones it does have. The building illustrated is now a school – Dixon's Trinity Academy – but it did not begin life as one, for it was the extension of a site occupied by the Bradford and Airedale College of Health. In 1996 it became a part of the University of Bradford, when it was known as the Unity Building. It closes-off an earlier hospital building of the twentieth century, built in an austere style with storeyed semicircular bay windows.

Dixon's Trinity Academy, 1994.

The new block was built in 1994 with tall semicircular bay windows and entrance, which echo the earlier work, the red-brick construction with buff brick bandings giving it a warmer, softer feel than the original building. There seems to be some influence of the American postmodern architect Robert Venturi and his work in the 1980s, who had used brick in similar designs. It is also postmodern in the ways in which, while using modern techniques of building, the architects, Langtry-Langton, have taken an over-the-shoulder glance at the original building on the site as well as neoclassical designs of the early nineteenth century, providing the double coding that Jencks has identified as the essential distinctiveness of postmodernism.

12. Mitchell Brothers (Now NHS Fitness Centre), Bowling Old Lane

Mitchell Brothers were one of the early and outstanding firms in the Bradford trade. As stated in the introduction, Bradford's expertise in nineteenth-century textiles was not so much in the production of all-wool cloths, but in mixed-fibre fabrics and linings, and it was in this that Mitchells excelled as spinners of mohair and worsted yarns.

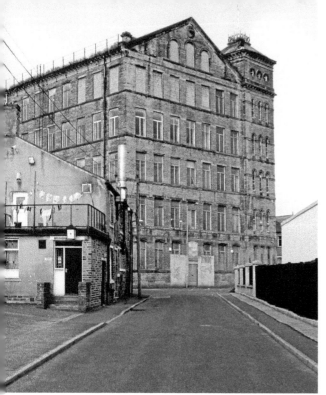 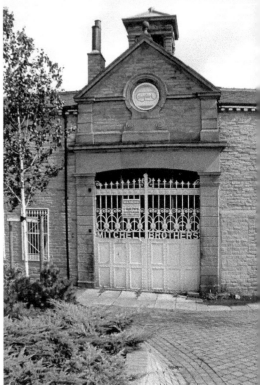

Above left: Mitchell Brothers, mill warehousing.

Above right: Mitchell Brothers entrance.

The origins of the Mitchell family are as farmers and clothiers of Bowling in the eighteenth century. They were a large family that formed partnerships with other Bradford textile families in the following century, providing a complex story of family loyalties and business know-how, but suffice to say that by the 1850s and after they had become established as Mitchell Brothers in two mills near the bottom of Manchester Road. The principal partners were the brothers Abraham and Joseph Mitchell who were to extend and rebuild the mill site between 1850 and 1880, eventually producing a complex of mill buildings, warehousing and stabling that straddled Bowling Lane. The spaces in between were filled with short rows of back-to-back housing, corner shops and the odd beerhouse – a typical urban-industrial life world.

Much of this has been pulled down, but a glimpse remains in this view along Albany Street to Bowling Old Lane. To the left is a remnant of early back-to-back housing and what was once a beerhouse. The building that terminates the view is the huge mill warehouse. It is built of local sandstones with plain and seemingly endless registers of windows as it rises through five storeys. The gable, however, contains an arcade of three round-headed windows, echoing the arches in the staircase turret to the right, which has its own pyramid roof, topped-off with iron cresting. In common with many of Bradford's textile sites and monuments, much of the area and mill complex have been cleared away, yet vestiges remain of this once prolific industry, such as the mill gateway with the name 'MITCHELL BROTHERS' forged in iron, standing Ozymandias-like amid the ruins.

13. Bolling Hall, Bowling Hall Road

Bolling Hall is Bradford's 'country house in the city'. It is also Bradford's only visible medieval domestic building. While other buildings of medieval date may exist as fragments of earlier buildings within later ones, a complete tower has survived at Bolling. This is sometimes described as a pele tower (a defensible tower), but this seems unlikely considering the size of both the door and windows. It is constructed of courses of rubble, and, if it did indeed start life as a defensible tower, it would seem to have been remodelled in later centuries. Given that the room on the first floor above the entrance contains fair detailing in its internal fittings and possesses its own jaques (a primitive lavatory sometimes referred to as a garde robe) in the turret to the left, it was probably a solar tower, an exclusive apartment of the lord and lady of the house to which they might withdraw. The date of this interior is perhaps the late fifteenth or early sixteenth century. If so, this is significant since the Bolling family, whose seat this house once was, were to marry with another Yorkshire gentry family, the Tempests, and the interior remodelling may well be the work of Rosamund Bolling and Richard Tempest who were married in 1497.

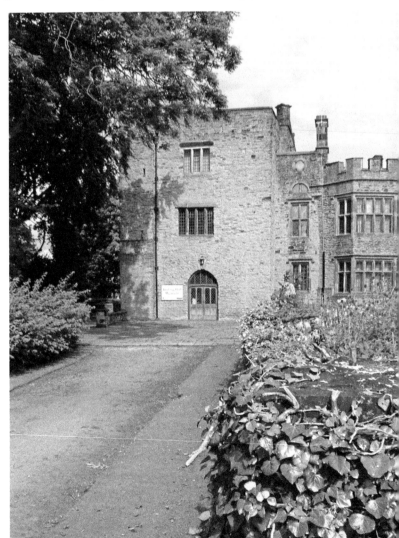

Bolling Hall,
medieval tower.

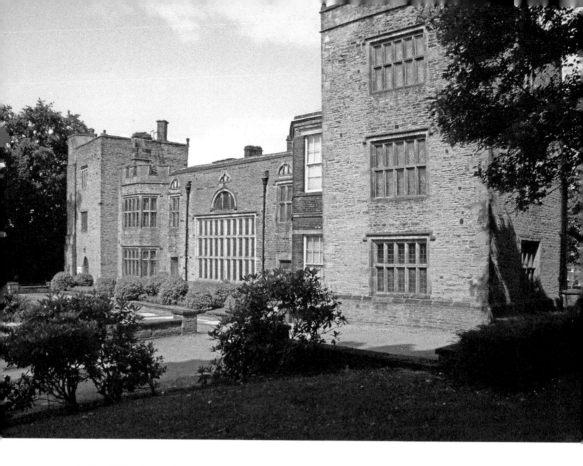

Bolling Hall, sixteenth century and later.

It is not possible to say what other buildings occupied the site, but during the sixteenth and seventeenth centuries an attempt seems to have been made to unify the garden front with a further tower at the opposite end. The configuration of this front in the seventeenth century would then have been a hall range framed by two towers. Wings have also been projected from the rear to give a courtyard entrance. While much of this work is of the seventeenth century, further remodellings were to take place in the eighteenth century, the house passing through the ownership of a number of elite families, each adding to the architectural jigsaw.

Before 1800, Bolling Hall had occupied a rural position on the edge of Bradford and overlooking parkland. But after 1800 Bradford's unstoppable industrial progress had already begun. One of its last landed owners, Sir Francis Lindley Wood, was to sell the estate to the Bowling Iron Co. and the house became a company residence. The ironworks themselves lay to the north-east; to the north-west, a huge dye works was eventually built. Even by 1829 the compiler of Jones and Company's *Views of the Seats, Mansions, Castles, etc., of Noblemen and Gentlemen* could comment that Bolling Hall was situated 'at the head of an extensive and fertile valley, deformed by a great profusion of worsted manufactories, with their attendant steam engines'. By the late nineteenth century the house had become enmeshed in the urban industrial sprawl and was tenemented. In 1912, it was presented to the corporation by G. A. Paley, its last owner. Bolling Hall is now a country house museum owned by Bradford Metropolitan District Council.

14. St John's, Bowling

The Bowling Iron Company was in production by the 1780s. It was one of five large ironworks in the Bradford district, but perhaps the most prolific. From small beginnings the company grew into a vast undertaking, eventually occupying around 26 hectares (or 64 acres) yet was situated overlooking Bradford only 1.5 kilometres or so from what we would recognise today as the city centre. To operate such a large works, large amounts of labour were needed, and this, together with an already rising population, sent Bowling's population up from 2,055 in 1801 to 8,918 in 1841, creating demand not only for housing but also for such amenities as places of worship. In this respect the Bowling Company had been criticised publicly for failing to attend to the religious needs of the area.

St John's was the company's response. It is situated on the southern perimeter of the ironworks next to one of the arterial roads leading out of Bradford, Wakefield Road. The architects were a York firm – R. H. & S. Sharp – who, in 1842, provided a competent Gothic design whose most prominent feature is the spire. One could say this of many churches, but at Bowling its location high above the town and the absence of other neighbouring churches add a landmark quality to an otherwise conventional design that could have been taken off the shelf of many an architect's office in the 1820s or 1830s. Yet it is not exactly true to call

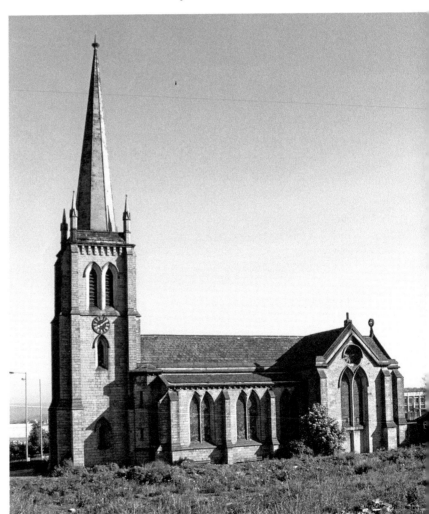

St John's, Bowling.

it conventional, for the interior nave arcade and other detail is constructed of iron. Whose idea this was is uncertain, but, according to William Cudworth in his *Histories of Bolton and Bowling* (1891), the architects had worked closely with Fred Stott, the company's chief engineer, in the design of the castings used. The architects were probably also influenced by similar work carried out by the architect Thomas Rickman and the ironfounder Thomas Cragg at St George's, Everton, in 1812–14.

Today, St John's stands in a landscape different from its nineteenth-century setting, but just as uninviting: a dual carriageway roars past its eastern end, the ironworks has gone, industrial units occupy the site and grass grows reluctantly on some of the old spoil heaps.

15. Bowling Police Office, Wakefield Road

Small as this building is, it has a lot to say about Victorian Bradford. One of the many problems that faced rapidly industrialising towns like Bradford was law and order. Before the 1830s law and order was the shared responsibility of a number of different authorities, but principally a constabulary working with the magistracy. This was not, however, a police force in the modern sense, nor one that was capable of dealing with an increasing and changing industrial society. Consequently, numbers of measures concerned with policing were brought into being throughout the nineteenth century, the Municipal Corporations Act of 1835 being particularly important. This allowed municipal boroughs to form a watch committee for the policing of a borough. Once Bradford had achieved municipal borough status in 1847 it was quick to act, forming a watch committee and a borough police force. A central police office had been established in Bradford in 1839 and this

Police Office, Bowling, *c.* 1859.

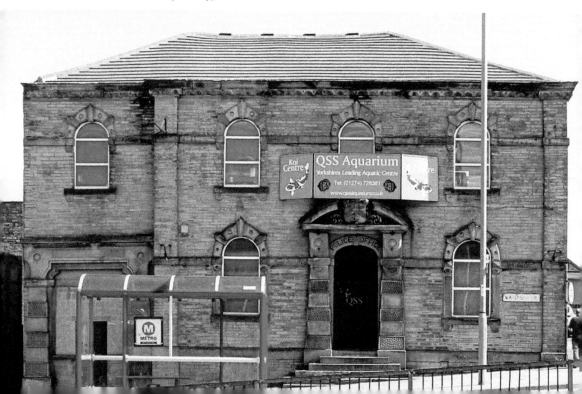

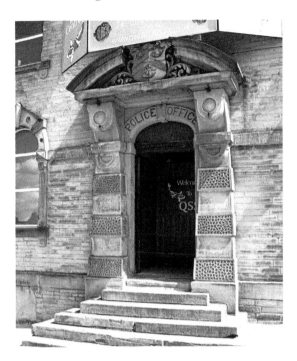

Doorway.

became the offices of the new borough police, but as the population grew further offices were needed in the out-townships – these were being built by the late 1850s.

Bowling Police Office seems to have been built around 1859. It is constructed from a fine sandstone that acts as a backdrop to the strong detailing of the windows and doorway, which all have blocks in their surrounds. The door frame in particular supports a heavy pediment containing the civic arms, a reminder, perhaps, of the civic motto, 'Work Conquers All' – not crime. It is also worth noting that the large, now blocked, opening to the left once accommodated a small fire station. It was a common practice throughout mid-nineteenth-century England to combine the functions of fire and police in one building.

Buildings such as this are easily overlooked, yet they reflect an essential difference of the Victorian town and city as modern patterns of social regulation were being established.

16. Shree Laksmi Narayan Hindu Temple, Leeds Road

To narrate the story of Bradford's religious diversity and the buildings to which it has given rise is a book in itself. Yet this needs to be referenced in the present work, for the city's architectural development in recent years has been enriched by purpose-built places of worship by people from different cultures and religions, and these need special mention as some of the new building types and architectural styles that have appeared over the past fifty years or so.

While the largest minority ethnic and religious group in Bradford is Muslim of Pakistani heritage, Hindu families of Indian heritage are a further significant group. According to the 2011 census, 4,882 people declared their religion as Hindu, but this figure may well under-represent Hindus in the city. Like many other migrants from Commonwealth countries,

those from India began to arrive and take up residence in Bradford from the 1960s. In that decade, few demands were made for a place of worship, yet it is worth noting that in 1968 the Hindu Cultural Society of Bradford was formed. Thus, as numbers of worshippers grew in the 1970s and 1980s, the society acquired a former social club in Leeds Road to convert to a temple. When this, in turn, proved inadequate, a new temple was planned at the beginning of the twenty-first century. The Shree Laksmi Narayan Temple/Mandir was the result. The mandir was designed by a local firm, Pickles Architects. The foundation stone laid in 2006, and the opening in 2007 was attended by the Queen and Prince Philip.

The mandir occupies a site on falling ground. This has been utilised to provide a building on two levels, consisting of the shrine and a prayer hall, together with a community centre. It is constructed of local sandstone. While it incorporates a decorative relief carving on

Hindu Cultural Society of Bradford.

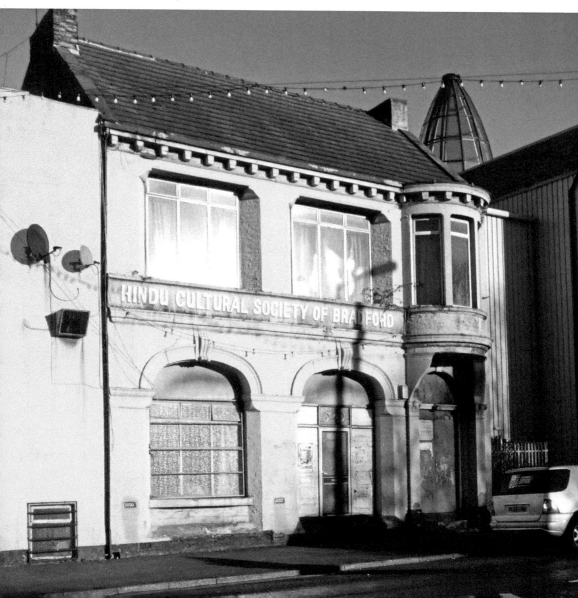

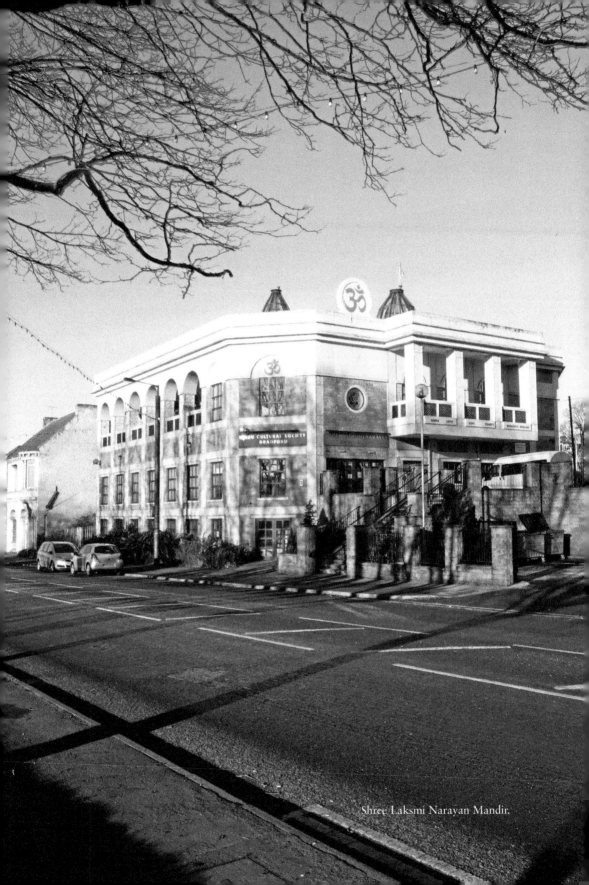

Shree Laksmi Narayan Mandir.

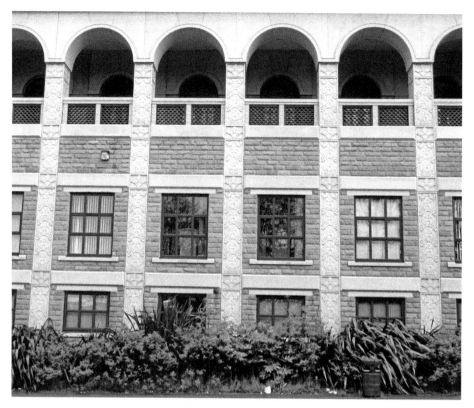

Shree Laksmi Narayan Mandir, exterior decoration.

the exterior, it is not the intensive display of sculptural relief seen at some traditional mandirs. Rather, its clean lines and massing suggest modernity, while the tall arcade to the Leeds Road reflects some of the nineteenth-century architectural development of the area. Tradition is present in the use of glazed roof cones to light the interior and the shrine.

The importance of the Shree Laksmi Narayan Mandir is not just the architectural impact it makes on its surroundings. Few Hindu temples had been built in England before the 1960s, the first, reputedly, was at Earls Court in the 1920s. Even today such mandirs are relatively few compared with the religious buildings of some other faiths, Islam, say. The Shree Laksmi Narayan Mandir represents a milestone in Bradford's religious history, for it claims to be the first purpose-built mandir in the north of England as well as the largest – attracting 2,000–3,000 worshippers.

17. Gatehaus, Leeds Road

The Gatehaus development is one of the city's more recent residential buildings (Robinson Design Group, 2006–07). The architects' brief was to design a structure in the centre of the city having a high density of residential occupation. It stands at an important entrance to the central area – on the edge of the Little Germany district (*see* page 43) – and contains 142 apartments, but also incorporates commercial premises at street level. To achieve this,

Gatehaus, Leeds Road.

the design consists of three parts: a glass-walled, lenticular 'shard', a curving stone-clad wall looking onto the Leeds and Airedale Roads and a further masonry block that closes the space to form a courtyard.

It is an impressive design that makes a dazzling impact close to the intersection of the Leeds and Airedale roads, two busy arterial roads into and flanking the city. But does it detract from its surroundings on this sensitive site next to the Little Germany conservation area? Clearly the architects were aware of this: the curving wall facing the Leeds Road seems to echo the semicircular façade of the former Congregational Chapel at the farther end of Little Germany; even if a shard is a contemporary architectural trend, when viewed from the Leeds Road it also suggests the prow of a ship, perhaps reflecting the nature of many of the shipping houses in Little Germany; and the building is generally in scale with its surroundings and in keeping with their tone and texture in the use of local sandstones in much of the walling.

Gatehaus, Leeds Road.

18. Feversham Street School

Before 1870 primary education rested with a number of institutions and individuals: grammar schools, schools run by religious denominations, numbers of public academies and private schools, dame schools (often run by spinsters or widows from their homes). There was no local and little state control, and standards and fees varied, yet there was financial support from central government. The Elementary Education Act of 1870 (Forster's Act) was taken through Parliament by the Bradford MP W. E. Forster, and provided for the primary education of children at modest rates through the setting up of local school boards that had the power to build and regulate new 'board schools'.

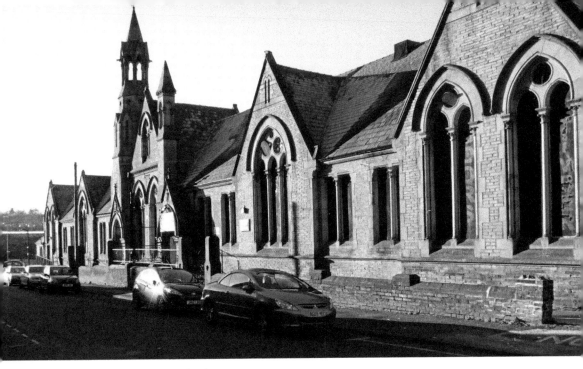

Above: Feversham Street School, 1873.

Below: Feversham Street School, rear.

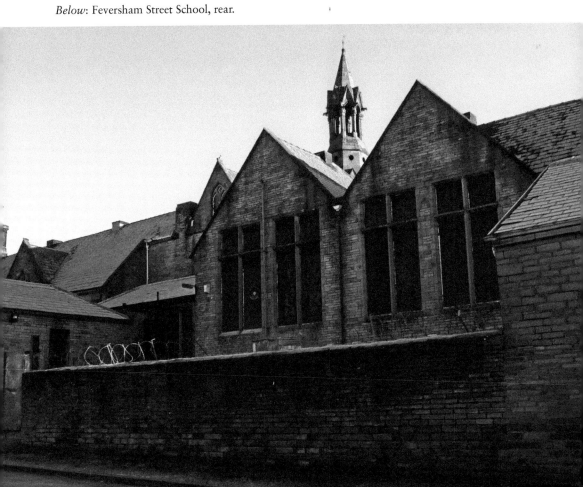

By 1872, the Bradford School Board had come into being and by 1874 had built eight new schools throughout the borough. The board did not stint on expenditure, commissioning Bradford's leading architectural practices. Feversham Street School was the work of Lockwood & Mawson, who produced a striking Gothic design, its main frontage consisting of a series of gables with tall Early English windows containing plate tracery (the pierced slabs at the tops). But its prominent feature is a tall spire above the entrance incorporating an open cupola. The choice of Gothic perhaps alludes not so much to the scholastic traditions of the Middle Ages as the Christian ethic on which education was predicated.

Despite all this, Feversham Street School had low attendance and did not meet expectations. The remedy that the School Board proposed was to use the school to provide more than an education in reading, writing and arithmetic, and (to use the terminology of the day) provide a 'higher grade' education for those who wished to take a wider variety of subjects; pupils would be taken from across the borough. This had both Her Majesty's Inspectorate's support and that of the government, and Feversham Street School became the first higher grade school in the country. While other towns and cities followed suit, by 1902 Bradford remained in the lead for this provision, possessing six of the nation's sixty higher grade schools.

By any measure Feversham Street School is a historic building, part of the nation's education heritage, hence its listing as a Grade II* building. Yet today it stands forgotten, neglected, used as a builder's merchants and DIY store. Given the past pride and enthusiasm with which both Bradford Council and Bradford MPs advanced education in the nineteenth century, the state of this building is woeful.

19. Gurdwara (Formerly the Sion Jubilee Baptist Chapel), Peckover Street

Perhaps no other place of worship illustrates Bradford's religious complexity better than the building illustrated. Bradford, along with Bristol and Birmingham, was one of England's hubs of the Baptist faith. Originally a Sion Baptist Chapel was located on Bridge Street and near to the then Lancashire and Yorkshire railway station. This was an area being developed with a railway goods yards and warehouses as the trade of the town expanded. Attendance at the chapel was also growing, and the Baptists were able to remedy this situation by acquiring another site for a chapel in Peckover Street and selling their original chapel and land to the railway company. The price negotiated seems to have been a handsome one, for they were to commission the town's leading firm of architects, Lockwood & Mawson, who, in 1871, produced a strongly Italianate design with a temple front. Any flatness in the design has been compensated for by the use of Corinthian columns and further decorative elements in the pediment, such as the date tablet indicating the completion of the chapel.

But the story does not end there. As nonconformity in Bradford began to wane in the twentieth century and attendances fell, the chapel was sold. In the 1960s, it was used by Bradford Technical College for their Department of Mechanical Engineering; in the 1970s, it became the home of an Italian social club, until finally it was to become a Sikh gurdwara. Like the Hindu community, the Sikh community in Bradford is a small one (5,125 people stated they were of the Sikh religion in the 2011 census), but a significant one. The first gurdwara in the city was established in the 1960s in a warehouse in Garnett Street. It has since been demolished, but, as the years went by, several others were to follow. The former

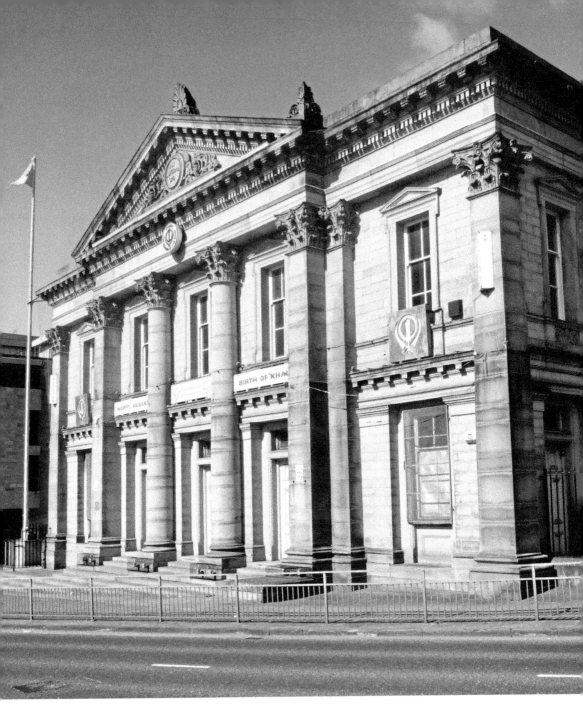

Sion Jubilee Chapel.

Sion Baptist Chapel was acquired in the 1980s by Amritdhari Sikhs, the chapel being restored and converted, opening in 1982. Rather like the Baptists of the previous century the Amritdhari of Bradford have links with branches elsewhere and attract visitors from other cities. Thus, as Bradford progresses into the twenty-first century, and its religious heritage becomes more diverse, more intricate, there also seem to be some intriguing parallels.

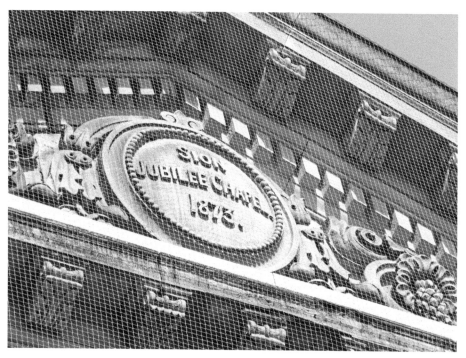

Date tablet.

Now a Sikh Gurdwara.

2c. Little Germany

The growth of textile warehouses in nineteenth-century Bradford is remarkable. This can be partly explained by a change to the way in which textile goods were marketed. No longer was yarn put out to spin at the behest of a master manufacturer or pieces of cloth 'exposed for sale' at a cloth hall, but both large and smaller manufacturers might deal directly with merchants on their own premises. A further important development was the establishment of large merchant houses, often export houses that began to build company warehouses in the city.

Bradford's textile warehouses were built mostly after 1850 and located between the two rail heads of Exchange station and Forster Square station and contiguous areas. They were of two types: home, dealing with the UK market, and shipping, dealing with exports. There was a particularly strong market with Germany for yarns and other textile goods, and several German shipping houses set up their businesses in an area leading from Forster Square past the (then) parish church and towards Leeds Road. It appears to have been given the names 'Germania' or 'New Germany', while, according to John Roberts (*Little Germany*, 1977), 'Little Germany' appears to have come into common use after the 1870s, although the first references seem to have appeared in the *Bradford Observer* in the 1860s.

Little Germany, Law Russell, 1874.

Little Germany, Thornton, Homan & Co., 1871.

Little Germany is set on a sloping, awkward sort of site that soon became crowded with textile warehouses, often built on wedge-shaped pieces of land. This led the architects of some buildings to place principal entrances at the apex of the wedge, with goods entrances around the corner on a long side. This can be seen in the Law Russell warehouse in the foreground (Lockwood & Mawson, 1874), where the portico is supported on crisply carved Corinthian columns of superb quality. This entrance rises through a further six storeys incorporating another four porticos – one above the other, diminishing in scale. In the background is the warehouse designed for Thornton, Homan & Co. (Lockwood & Mawson, 1871) with its carefully graded registers of windows and looking like an Italian Renaissance palace. Not all businesses in Little Germany, however, traded with Germany. Thornton, Homan & Co. were a shipping house dealing with China and North America, the latter country symbolically represented by star-and-stripe motifs in the medallions above the first-floor window heads and the vigorously sculpted eagle above the entrance.

Within this district of the city characterised by its narrow streets and tall buildings are some of the finest textile warehouses in the UK.

21. Bradford Cathedral, Stott Hill

Medieval Bradford was a settlement of uncertain status. It was larger and more diverse than a village, yet had no characteristically urban form of governance. In short, it is difficult to decide whether it was a town or not. Its church was like that of many a medieval village,

although it was central to a large parish. Although there is no mention of a church at Bradford in Domesday Book, this does not rule out the possibility, since the compilers of Domesday did not consistently list chapels and it is possible that Bradford's place of worship at this date may have been a chapel dependent on the church at Dewsbury. But, judging from documents of the thirteenth and fourteenth centuries, a church had either been built or possibly rebuilt; however, this was not the existing church, which dates from a building campaign of the mid-fifteenth century to the sixteenth century. The medieval parts of the exterior seem to date mostly from this Perpendicular period and are a rebuilding of the central body, which was said to have been begun around 1430, continuing until the 1460s. The north side contains some of the original panelled tracery windows of the mid-fifteenth century, while other 'medieval' parts of the exterior are the result of nineteenth century repair and rebuilding. The tower seems to have been added later and probably dates from between 1490 and 1510, and is the least altered part of the church. It is of sturdy construction and, like the rest of the church, of local sandstone.

One of the problems in interpreting the present church is that many centuries have left their mark on it, but especially the nineteenth and twentieth when it underwent substantial remodelling and extension. The mark of a city is a cathedral, the seat of a bishop, and although Bradford was designated a city in 1897, it was not until 1919 that its parish church was given cathedral status. In keeping with this, it was remodelled, although not

Bradford
Cathedral,
mid-fifteenth
century and later.

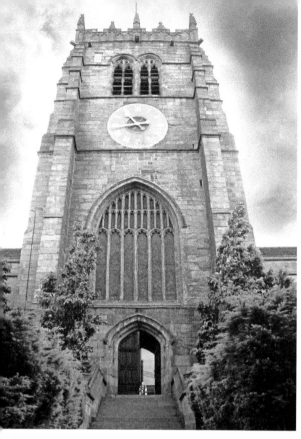

Left: Bradford Cathedral tower 1490–1510.

Below: Bradford Cathedral, twentieth-century remodelling.

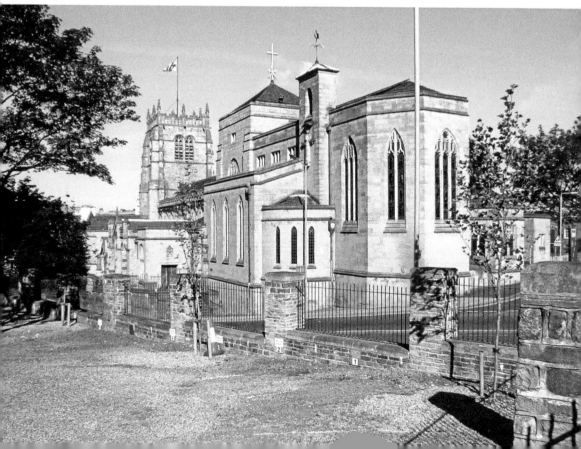

until the post-war years under the direction of the architect Sir Edwin Maufe. First came the remodelling of the western transepts in 1954; next, the eastern end between 1958 and 1963, resulting in a polygonal Lady chapel and a new chancel, with glass from the old chancel windows by Morris & Co. being reinstated.

This description only covers some of the major changes that have occurred, but most ages have left their mark, and, as with many churches, not every piece of the architectural puzzle can be neatly fitted together.

22. The Midland Hotel, Forster Square

It was perhaps railway hotels like the Midland that introduced luxury accommodation to the travelling public. The Midland Hotel is an example of that, and when first opened had 115 bedrooms. Its census entry for 1901 also gives some idea of the complex social mix of Bradford by the end of the nineteenth century, a place where business was transacted on an international scale: the manager of the hotel was German; waiters came from England, Scotland, Germany and Italy; there were two French chefs; and guests were from England, France, Germany and America.

But this was all predicated on the arrival of the railway. The first station on the site was for the Leeds & Bradford Railway in 1847, but this was taken over by the Midland

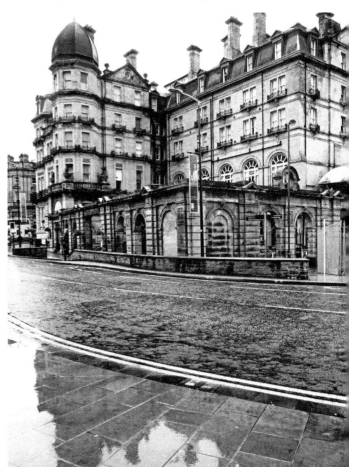

Midland Hotel, 1885.

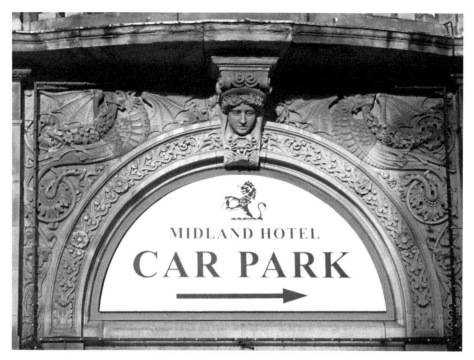

Midland Hotel door head.

Railway and later rebuilt. The whole station was again remodelled in 1885 by the Midland's architect Charles Trubshaw, who designed a station complex that included the present hotel. Trubshaw designed in a style that had become common from the 1880s and has been characterised as a Northern Renaissance style. It consisted of the free application of classical elements to often traditional forms of building; balconies, arches and panels of relief decoration (arabesques) were also employed. Here, for example, Trubshaw has decorated the entrance from Forster Square with a cool classical female mask on the keystone of the arch above the door and at each side incorporated reliefs of Midland Railway wyverns, the company's emblem. The turret at the corner of the building has been given a tall dome to create greater impact, but unfortunately this has been clad in a black roofing felt – its original covering was zinc. The enclosing wall was once the entrance to the station itself, but, alas, the Trubshaw station no longer exists, and has been replaced by a nondescript collection of buildings. Only the hotel remains.

23. The Wool Exchange, Market Street

You are going to spend 30,000l.,which to you, collectively, is nothing … But you think you may as well have the right thing for your money. You know there are a great many odd styles of architecture about; you don't want to do anything ridiculous; you hear of me, among others, as a respectable architectural man-milliner; and you send for me, that I may tell you the leading fashion.

John Ruskin, 'Traffic' in *The Crown of Wild Olive* (1882)

So spoke John Ruskin to the assembled great and good of Bradford in 1863 when they had invited him to speak to them about an appropriate design for a new exchange. Despite Ruskin's somewhat supercilious tone, this invitation does show how seriously Bradford's industrial elite took this addition to their town. By the 1860s Bradford was becoming not just the centre of the worsted industry in Britain, but the world. The Wool Exchange would represent this as it became an international trading floor for wool, hair and fibres.

In terms of its architecture, Ruskin went on to suggest that one model might be the Venetian Gothic that could be seen in near perfection in Alfred Waterhouse's work in Manchester at the assize courts. A competition for the design of the new exchange ensued and resulted in Lockwood & Mawson's submission being accepted. Although they are said to have visited the assize courts, the building they produced seems to have little to do with the Gothic of Venice and more to do with Flemish architecture, especially the cloth hall at Ypres. Constructed of red and buff sandstones, it stands on an awkward wedge-shaped site, the entrance being designed as a Flemish-looking Gothic tower at the apex of the site. The ground floor consists of a grand arcade of pointed arches (here a similarity with Ypres) and between these, the sculpted heads of inventors, politicians and industrialists important in the development of the textile industry, trade and commerce. Their stony stares, however, seem forbidding rather than dignified. The entrance in the tower is also richly sculpted with legendary figures important to the textile industry, such as St Blaise, patron saint of wool

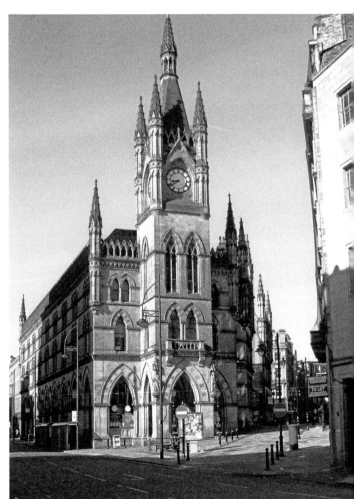

The Wool Exchange, 1864–67.

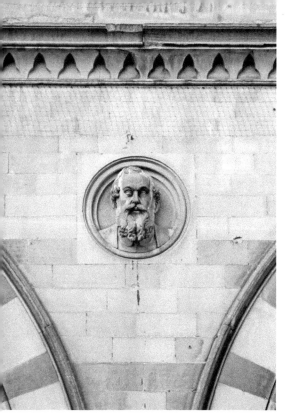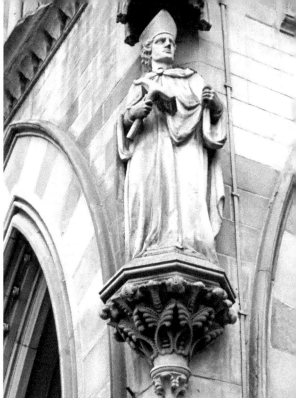

Above left: Wool Exchange, Sir Titus Salt.

Above right: St Blaise.

combers – here he holds a wool comb in his right hand. The foundation stone was laid by the prime minister, Lord Palmerston, in 1864, and the building was completed in 1867. The trading floor occupied the ground floor with offices above, part of which was taken up by the offices of the architects Lockwood & Mawson.

The Wool Exchange ceased trading as such in the 1960s; it is now a book shop.

24. The Shoulder of Mutton, Kirkgate

Bradford gives the impression of a largely Victorian city that has continued to grow in the twentieth century. This is true, and traces are few of that earlier town within the central business district. The Shoulder of Mutton is one of these rare survivals. The building is dated 1825 on a keystone above the main entrance, together with the initials 'E. W.' – Elizabeth Wilson, the publican who rebuilt an older Shoulder of Mutton on the site. It is built of sandstone in thin courses and the decorative detailing consists of a semicircular head to the doorway and a moulded surround to the window above, both rather eroded. The sash windows, although they seem original, have all been reglazed later in the nineteenth century and would have contained small panes. The large entrance to the left would have originally allowed access for carts and carriages to a rear courtyard where stables and warehouses were once located.

The Shoulder of Mutton was one of several inns that provided accommodation along Kirkgate, a principal thoroughfare. These were also places where friendly societies might

Shoulder of Mutton, 1825.

meet, or clothiers might transact business with merchants. Its location – almost opposite Bradford's former textile piece hall (now demolished) – gave the Shoulder of Mutton an ideal position for this commerce, and trade directory entries confirm that numbers of worsted manufacturers transacted business there. However, this was a practice whose days were coming to an end even as it was rebuilt.

Some of the character of this former inn survives internally also, making it one of a very few central pubs that dates from before the great Victorian rebuilding of the town.

25. St George's Hall, Hall Ings

The centre of Bradford in 1850 was unimaginably different from today, or even 1900. It was an unwholesome amalgam of factories, foundries, breweries, beerhouses, dram shops and poor back-to-back housing. Public buildings were few, the most prominent being the West Riding Court House erected in the 1830s, a symbol, though hardly a guarantee, of law and order – serious rioting by physical force Chartists had taken place in May and June 1848 when the constabulary had been routed and the streets became occupied by the military.

It was often remarked by social reformers of the nineteenth century that, while concert halls and museums were closed on Sundays, all the public houses were open. St George's Hall was Bradford's response to such conditions. Funded through the share capital of a private company, the foundation stone was laid in 1851. The architects were Lockwood & Mawson, then a new practice in the town. Their early work was usually in a classically influenced style, often Italianate, and St George's Hall is no exception. It stands on a central site, an Italian urban palace, similar in feel to Palladio's work in Vicenza – the Palazzo Iseppo Porto, for example, comes to mind, or Bramante's House of Raphael, both models for many a Victorian bank or public building. The entrance front on Hall Ings is in a massive

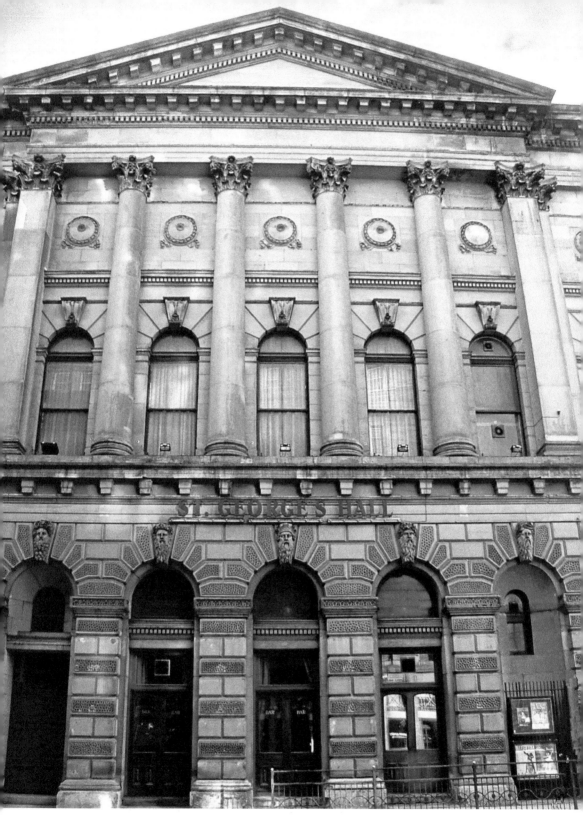

St George's Hall, 1851–53.

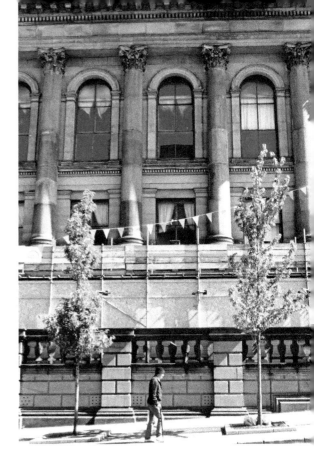

St George's Hall from Bridge Street.

rusticated arcade, rising from which is a temple front. It is a building fit for a Renaissance prince, but this was a people's palace open to all. And its purpose was clear, for, as the *Daily News* commented in August 1853, it supplied 'a want much felt in Bradford' for a central concert hall and also one that could accommodate meetings 'for social, moral or religious purposes'. It should also be recognised that St George's Hall had a further importance: it was the first building in Victorian Bradford to spark off a kindling of civic pride that was to result in the rebuilding of much of central Bradford over the next fifty years. Now it stands empty and dilapidated, and at the time of writing is awaiting refurbishment.

26. The Prudential Assurance Company Building, Sunbridge Road

Banking and insurance were risky businesses in the nineteenth century, and perhaps for that reason financial institutions were keen to erect substantial premises suggesting stability and permanence. The Prudential Assurance Company went one stage further. Founded in 1848 as a mutual investment and loan company, by the end of the century it had become the country's largest provider of life insurance. In 1879, it commissioned Alfred Waterhouse – a well-respected architect who had received Ruskin's blessing – to design new headquarters in London. He provided a massive Gothic design in red brick and terracotta, materials that he considered best able to resist pollution. The company were so pleased that over the next twenty years or so Waterhouse and his son Paul were to receive a further twenty-seven commissions throughout the country. All were similar to the London office in both design and materials, thus promoting an immediate brand recognition, something that

Prudential Assurance Company, 1895.

no other company had attempted on such a scale, but earning Waterhouse the nickname
'Slaughterhouse' as a result of the relentless redness of his buildings.

The Bradford office proved no exception. Designed in a Northern Renaissance style,
the building stands on a pink-granite base, rising to four storeys in hard red brick and
terracotta with the company's name and insignia emblazoned on its two main frontages.
Identity, security, dependability are exhibited in Victorian splendour ... and yet this drive
to the corporate image is completely out of sympathy with its surroundings. In a city built
with local sandstones the Prudential building makes no concessions – even the brutalist
High Point (*see* page 67) is constructed of a buff concrete that tones with its setting, but the
Pru howls its unease like a dog in the night.

27. City Hall, Centenary Square

Bradford was incorporated as a municipal borough in 1847 and its first council came
to office in the same year. There was no town hall then and it shared premises in Swain
Street with the Watch Committee and the Central Police Office. But a growing town and
increasing commerce brought with it increasing civic administration. Civic pride combined
with the need for greater accommodation led to plans for a new town hall being discussed
in the 1860s. In 1869 a competition was held, the winners being Lockwood & Mawson.

This new town hall was completed in 1873 and is a complex, composite design. The
main body is influenced by French Gothic cathedral architecture, particularly that of
Amiens, while the tower is based on that of the Palazzo Vecchio in Florence. However,
controversy dogged the design from its beginning. Outraged letters to the architectural
press accused Lockwood & Mawson of drawing heavily on William Burgess's design for
the Law Courts in London, which had been published in 1867. There may have been

Right: City Hall.

Below: City Hall entrance.

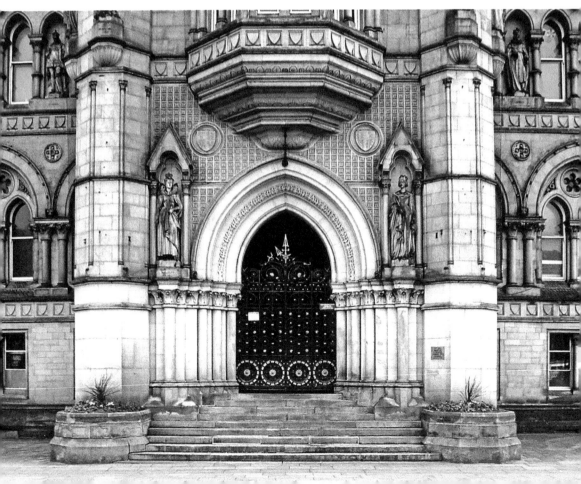

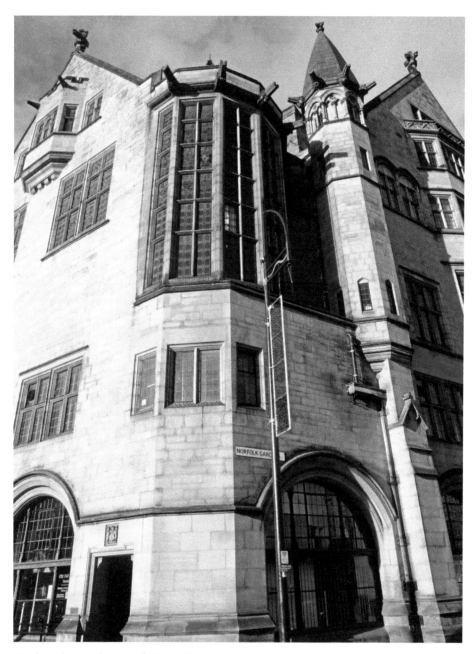

Oriel window to the rear of City Hall.

some truth in this, although Lockwood & Mawson denied it. Whatever the rights and wrongs, the architects produced a town hall to rank alongside other town halls of the industrial north of England, such as Rochdale or Manchester. Particularly striking is the series of niches above the first floor containing sculptures by the London firm Farmer & Brindley, of the kings and queens of England in the company of – unusually – Oliver Cromwell. The most symbolically important are the figures of Elizabeth I and Victoria

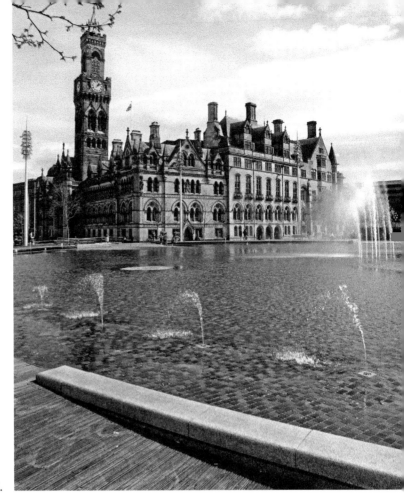

Shaw extension and pool.

that flank the entrance, monarchs that could be associated with enterprise, success and nationhood.

By the beginning of the twentieth century the building again needed to be extended. In 1909, Richard Norman Shaw (one of the outstanding architects of the nineteenth century and aged eighty at this time) was commissioned to carry out this work, which was supervised by the city architect, F. E. P. Edwards. Shaw's work to the rear of the building is sometimes overlooked, but it links with the earlier work without detracting from it, and it contains impressive oriel bay windows.

The building still serves as a town hall although in 1965 its name was changed to City Hall to reflect its status. More recently a pool and fountains have been created to fill the space on the west side of City Hall. This work took place between 2011 and 2012 to create an urban park, which boasts that it is the largest urban water feature in the UK.

28. Providence Mill and Thompson's Mill Site, Thornton Road

It may seem strange in a book about the architectural riches of a city to show a derelict industrial site, but this one is important for two reasons. Firstly, it is only 100–200 yards from the former Odeon Cinema (*see* page 59) in the centre of the city, demonstrating how close industry once was to the central business district. Secondly, this area of Bradford is where

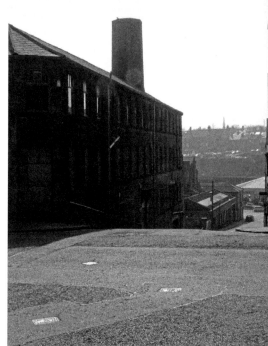

Above left: Providence and Thompson Mill site.

Above right: The derelict mill site.

the mechanisation of the textile industry began around 1800. The first mill, Holme Mill, had been located opposite this site, and others followed. They began as cotton and worsted spinning mills, but by the mid-nineteenth century they were enlarged, with some having the capacity for weaving too. Thompson's Mill, the site from which the photograph is taken, is one such example and in the background is Providence Mill, with a series of taking-in doors in its gable. Such mills may lack the architectural refinement of some later ones, yet they are more typical of the Bradford mill: stone-built industrial complexes, their workforces living in narrow streets of back-to-backs and terraced cottages that filled the spaces in between. Much has been swept away now, with Providence Mill and the site standing empty and forlorn.

This is a sensitive site given its historical provenance. Recent fires in derelict mill buildings and the resulting demolitions provoke debate about the future development of the area, and invidious decisions that will need to be taken.

29. The Odeon Cinema, Prince's Way

We perhaps tend to think of the leisure complex as something invented in the late twentieth century, but its origins go some way further back. The Odeon Cinema is a good example. When it was built in 1930, it was one of the largest cinemas in the country – and more. Its stage could be used for theatrical events or shows; it had an orchestra pit and a Wurlitzer organ; there was also a ballroom; and one could dine there. With seating for above 3,000, it was probably one of the largest buildings in the city, with exceptions such as City Hall and the railway stations. The designer was William Illingworth, a Bradford architect who had designed other cinemas. He provided a classically inspired design that was already becoming old-fashioned by the 1930s and which, in essence, dates back to the beginning

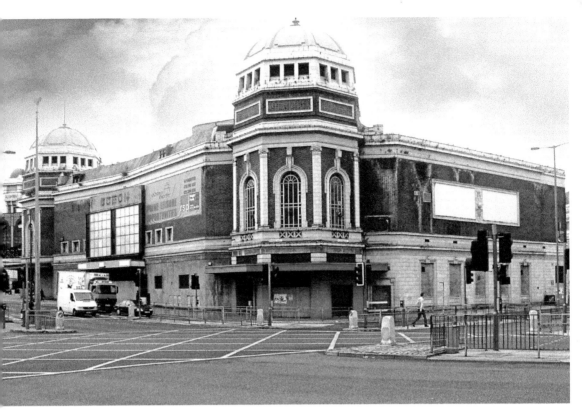

Odeon Cinema.

of the twentieth century. Two sturdy towers anchor its sprawling mass and have white-tiled decoration to the window surrounds, pilasters between the windows and the drums of the domes. The walling is brick that rises from a white-tiled base. It is difficult to describe the impression it conveys, since it is a heavy-looking mass of building with three street frontages, two of them almost blank. Yet despite its clumsy appearance, it unites the architectural landscape along Prince's Way and up Godwin Street, the twin towers of the Alhambra Theatre linking with the Odeon's towers, which, in turn, are echoed by Sunwin House.

The cinema was originally named the New Victoria. In 1950, it was renamed the Bradford Gaumont and in 1969 it reopened after alterations as the Odeon Twins. Declining numbers resulted in closure in 2001, and plans for its demolition have so far been successfully opposed by campaigners.

3c. The Alhambra Theatre, Prince's Way

As the Victorian town developed after 1850, it became well endowed with places of polite entertainment, concert halls and theatres. The first of these was St George's Hall (above) in 1853, but others followed, among them the Theatre Royal (1864), the Palace (1875) and the Prince's Theatre (1876) – all now demolished. Bradford could attract leading touring groups and actors, and even has the dubious honour of being the place where the renowned Victorian actor Sir Henry Irving gave his last performance in 1905, dying later that evening at the Midland Hotel.

Theatre development continued in the twentieth century with the building of the Alhambra Theatre in 1914. It was built for Francis Laidler, an impresario who had other theatres in the city. The Leeds firm of Chadwick & Watson, who had been responsible for

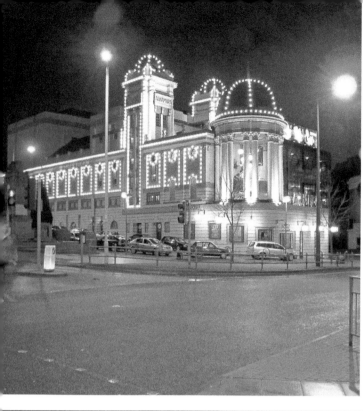

Left: Alhambra Theatre.

Below: Alhambra towers.

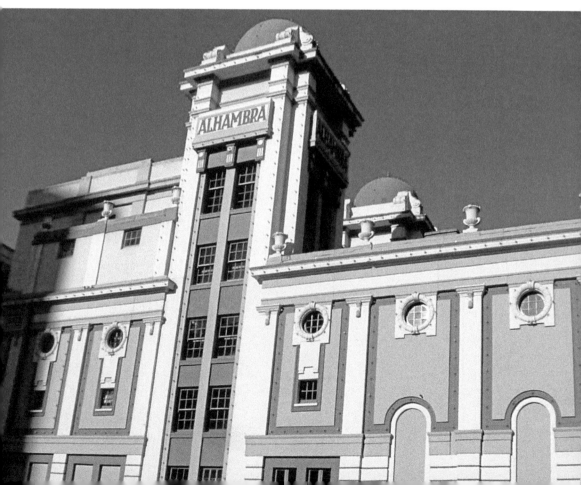

theatres throughout the country, drew up the design, describing it as 'English renaissance of the Georgian period'. As the architectural historian Derek Linstrum has commented, it is difficult to see how this bizarre description fits. Given its dome and two minaret-like towers – also with domes – it has something in common with the architecture of the mosque, if borrowing from the classical idiom. The name Alhambra would appear to signal this, but that is probably incorrect. 'Alhambra' may simply be a reference to the older Alhambra in Leicester Square, London, which also had three domes employed, like the name, for exotic effect. That being said, it was also a popular name for a theatre or music hall in the nineteenth century. However one cares to style the building, with a seating capacity of 1,800 it has provided entertainment from ballet to musicals, pantomime to drama, and has hosted some of the greats of the entertainment business – Laurel and Hardy, Frank Randle, Morecambe and Wise, Ken Dodd, Tommy Cooper. And, after extensive remodelling in the 1980s, it continues to do so.

31. The National Science and Media Museum, Prince's Way

Both the site and building that now houses the National Science and Media Museum have an odd history. The Victorian Prince's Theatre once stood there, but having ceased business in the twentieth century, it was demolished and a new road created in front – Prince's Way, part of the new inner ring road of the 1960s. A new building was erected in 1963, a prestige development

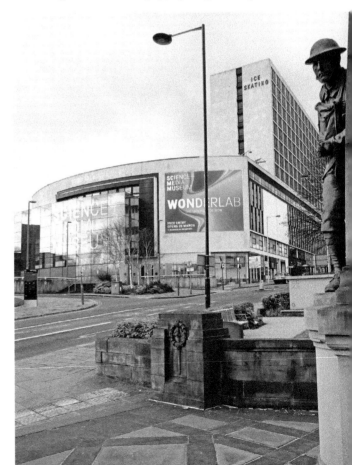

National Science and
Media Museum.

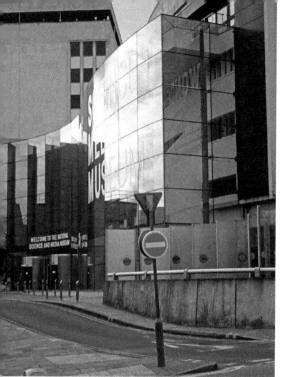
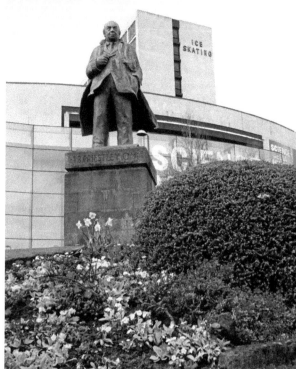

Above left: National Science and Media Museum entrance.

Above right: J. B. Priestley.

that was part of the replanning of Bradford in the post-war years. The architects chosen, as for some other buildings in this new, progressive vision of the city, were international practitioners held in some repute, in this case Richard Seifert & Partners. They designed a convex-ended block clad in Portland stone with a massive glazed window inserted, glaring at the city cyclopean-style, to the rear rose the tower of Wardley House. The whole was intended as a sort of civic arts and leisure complex – the Wardley Tower, for instance, contained the Silver Blades Ice Rink, which opened in 1966 and continues as an ice rink today.

Sadly, Seifert's design was never fully completed, and it stood empty for a number of years, failing to fulfil the original vision, but it became entangled in one of the city's more colourful events. In 1967, the building together with the library next door became one of the sites where Albert Hunt's 300-strong Bradford College Theatre Group re-enacted scenes from the October Revolution in a piece of radical street theatre to rival Eisenstein's *October*.

Matters took a turn for the better when, in 1983, it became the home of the National Museum of Photography, Film and Television, which was renamed (mercifully) the National Media Museum in 2006. At the time of writing it has again been renamed, this time as the National Science and Media Museum.

The harshness of the original building has been softened by the addition of a waved and glazed entrance extension in 1999, a reference, perhaps, to some of the Seifert firm's other commissions such as Gateway House in Manchester, while in 1986 a bronze statue of J. B. Priestley was positioned in front of and just below the museum. Yet, for all that, something of the drama of the original Seifert design has been lost. These buildings should also be considered in connection with the former Central Library and in the context of the Wardley plan for the city, outlined in the next entry.

32. Margaret McMillan Tower (formerly Central Library), Prince's Way

The Wardley plan was a scheme of town planning put together by the City Engineer Stanley Wardley, to modernise the city and to provide a trouble-free flow of traffic. This involved parts of the Victorian city being cleared away and new streets and buildings being built for a city of the future. Bradford's Central Library was part of that optimism. The library, designed in 1967 by W. C. Brown, the city architect, seems just another tower block at first sight, but look again. It rests on a rustic base of slate and rises clad in Portland stone as a chaste block overlooking the city centre. The stanchions (the vertical members) are also clad in slate producing a fine counterpoint to the Portland stone.

When first built it was more than just a library, since it also contained a gallery, café and theatre where plays, readings and lunchtime concerts might be heard. Alas, in recent years not only have these facilities been removed, but in 2013 the library itself was closed and moved to a smaller building near City Hall. The old Central Library building has now been refurbished, opened as office space and renamed the Margaret McMillan Tower after the Bradford socialist education reformer.

There has been much criticism of the Wardley plan over the years, for it did not solve traffic problems and it led to the demolition of many Victorian buildings that were characteristic of and gave character to the city. But the plan was never carried out as Wardley had intended. It was conceived in the spirit of civic virtue and was intended to promote such a culture. It is something we are beginning to lose, and the so-called Margaret McMillan Tower is perhaps symbolic of this decline.

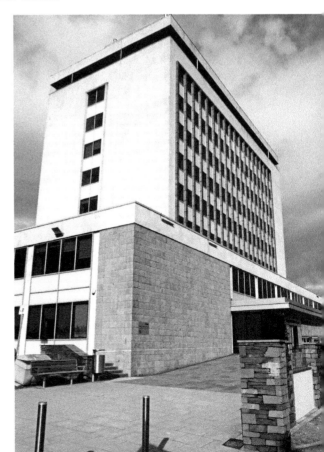

Margaret McMillan Tower.

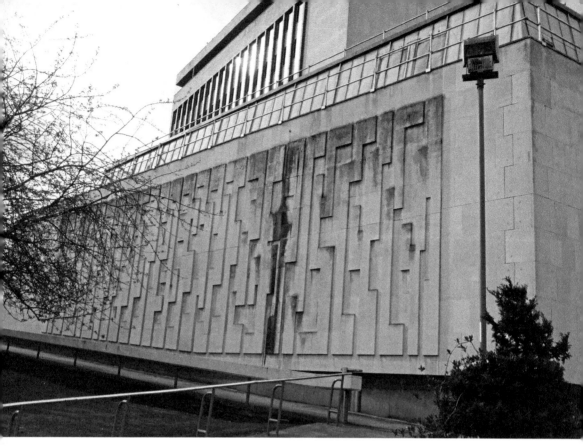

The former Library Theatre.

33. GPO Telephone Exchange, Manchester Road

From the beginning of the twentieth century the telephone was becoming an increasingly important channel of communication for business, but was also beginning to be installed in people's homes. As the century progressed, the telephone gained more and more users, so large exchanges had to be built in towns and cities. The General Post Office (GPO) had responsibility for this, and they tended not to use local architects but those working for the Office of Works. The architecture of the GPO is something that has been examined only recently and there is still more work to do (see Julian Osley, *Built for Service: Post Office Architecture*, 2010, British Postal Museum). Stylistically there seems to have been a move to design buildings in rural areas and country towns in vernacular or traditional styles, whereas in larger towns and cities classical styles of modern appearance might be employed.

In Bradford, the new telephone exchange was opened in 1939, and has been designed in an urban-modern style built of that favourite material of the interwar years, Portland stone. Superficially it seems a boring modern cube, but it is far more subtle: it rises from a rusticated base; its windows flow into each other, but are divided by aprons indicating floor levels; the doorway has a simply moulded granite surround with a keystone and the date. This is a much under-rated style of the 1930s – stripped classicism – and here it provides a sophisticated design to house a developing technology. The architect John Hutton Markham designed a number of telephone exchanges for the GPO and it is possible that he *may* have been the designer of this one.

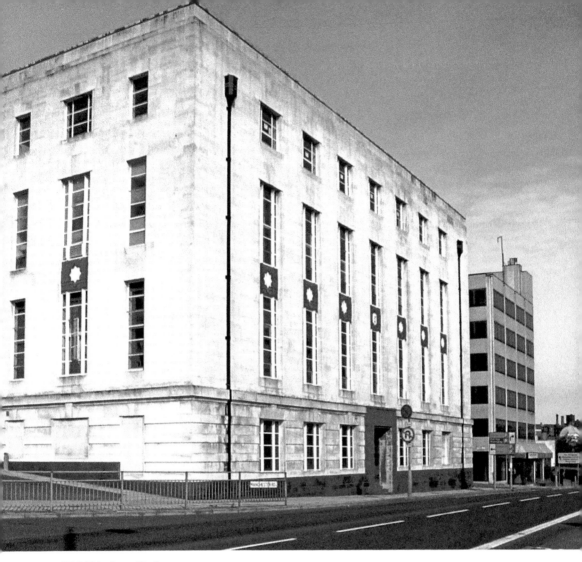

GPO Telephone Exchange.

34. Sunwin House, Sunbridge Road

Sunwin House is Bradford's outstanding interwar modernist building. Other than the Odeon on Manchester Road (constructed in 1938, and demolished in 1969), no other building speaks this era in quite the same way. It opened as a Co-operative Society store replacing an earlier shop on the site. It is heavily influenced by the international modern movement and, in particular, the work of Erich Mendelsohn, a leading German modernist. He had designed a department store in Stuttgart in 1928 for the Schocken family employing in its design a tower-like projection spiralling almost organically out from the building. It is the Schocken store that seems to have been the model not only for Sunwin House, but also the Co-operative Society store at Southport. The architect of both was William Albert Johnson, the Society's chief architect, assisted by J. W. Cropper, and in Bradford they produced a variant on the Schocken design using two towers, perhaps reflecting the towers of the store it replaced and echoing those of the Alhambra and New Victoria Theatres

farther down the road. It has sometimes been commented that Sunwin House was based on the De La Warr Pavilion at Bexhill-on-Sea (Mendelsohn and Chermayeff, 1935), but this is probably incorrect, since Johnson was already designing in this style as in the Southport store completed in 1934.

Although a listed building, Sunwin House now stands empty, forlorn and is beginning to become dilapidated, yet this is Bradford's premier international modern building. It should be better appreciated.

Sunwin House.

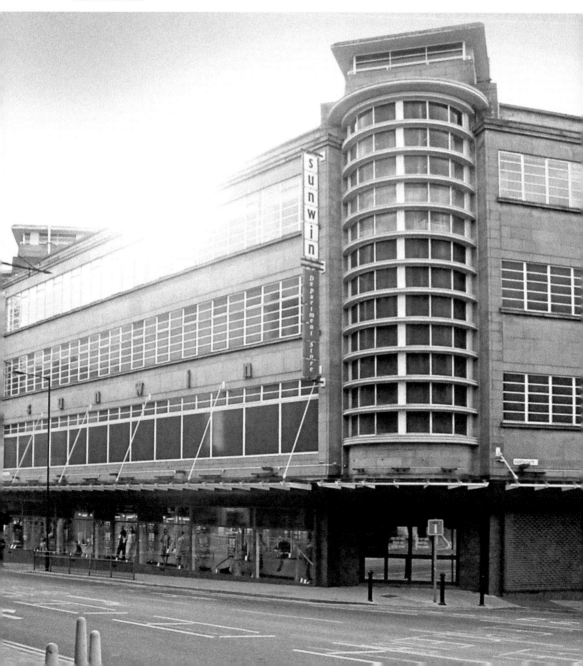

35. High Point (Former Yorkshire Building Society), Westgate

Building societies flourished in nineteenth-century Bradford, as they did in many nineteenth-century towns. They provided a means by which people of modest incomes might acquire a house. Some were terminating societies that ceased after houses were built and costs paid: a sort of building club. Others were permanent, continuing to build houses for members, taking new members and also investing members – savers. A great many houses built in nineteenth-century Bradford for both the middle class, and better-off sections of the working class, were brought into being as a result of the activities of such building societies.

Building societies today, of course, rarely build houses, although some are the heirs of these much older societies. The Yorkshire Building Society came about through the merger of a number of former societies, notably the Huddersfield Equitable Benefit Building Society and the Bradford Self-Help Permanent Benefit Building Society, to give them their Victorian names. This demanded new corporate headquarters for what became the Huddersfield and Bradford Building Society, then from 1982, the Yorkshire Building Society. This building became known as High Point. Completed in 1972, John Brunton and Partners were the architects. It is the city's outstanding piece of brutalist architecture – 'brutalist' being a play on the French '*béton bru*', meaning raw concrete, although other connotations, such as the brashness of such architecture, are obvious. Perhaps the most striking feature of the building is its long narrow windows, like arrow slits, giving the appearance of a castle keep, and perhaps that is the intention – safeguarding loans and investments. Its walls of corrugated concrete provide a texture, especially in strong sunlight, that gives the building more the feel of a piece of urban sculpture.

High Point.

High Point – wall texture.

High Point in urban context.

It is also a building that divides opinion. Many say that it is out of scale, cold and inhuman – brutal in every sense – and that it is out of sympathy with its surroundings. There is some truth in the latter in the way that it towers above its neighbours and the effect it creates, for in common with numbers of tall buildings, there can be an excessive turbulence in the surrounding streets, probably due to its height and siting. On the other hand, there has been a growing appreciation of brutalism in recent years (see, *Concrete Concept*, by Christopher Beanland, 2016), and were a competition held, then High Point should be a contender for a place in the top ten brutalist buildings in the region.

36. Council Housing, Longlands District

The area known as Longlands is bounded by Sunbridge Road, Westgate and Grattan Road; at the far end is St Patrick's Church. In the nineteenth century it consisted of several streets of small terraced houses, back-to-backs and lodging houses erected piecemeal and without regard for comfort or public health. By the later nineteenth century it had become one of Bradford's worst slums.

Council flats Longlands district.

Single-person dwellings at Roundhill Place.

A solution to this problem was proposed in the 1890s that provoked heated debate: municipal housing. Under the Housing of the Working Classes Act (1890) councils were empowered to clear slum districts and rebuild. There was much opposition to this on Bradford Council. Some opposed the whole idea, while others thought private enterprise or philanthropy the solution. The Catholic Church also objected to such a scheme, since it foresaw its congregation in this largely Irish Catholic area becoming dispersed. In the end, a scheme of municipal housing won the day under the leadership of Fred Jowett, the Labour chairman of the Housing and Sanitary Committee.

Clearance and rebuilding with apartment blocks took place between 1900 and 1910 and these were added to in 1918 by the single-person dwellings illustrated, designed by William Williamson, the city architect. This is modest accommodation, but the simple detailing gives it a dignity that much working-class housing lacked. It was Bradford's first venture into council housing, and it is gratifying to see that some have recently been restored and continue to provide homes.

37. St Patrick's Church, Sedgefield Terrace

It is a mistake to think that Irish migration to Britain was the result solely of the potato famine of the 1840s. There had been migration before that date, and it continued afterwards. The most intensive period of migration was, however, the result of this tragedy. In percentage terms, Bradford had the highest concentration of Irish familes of any Yorkshire town. By 1851 between 8 per cent and 10 per cent of the population was Irish.

There was a small group of Catholic families in Bradford before 1840 who worshipped at a small church near to the present-day cathedral. But a rising population of predominantly Roman Catholic Irish migrants, led to the need for further churches. A large area of such Irish settlement was in the area known as Longlands, mentioned previously, but also running to the north-west along Black Abbey and White Abbey. It was on the edge of this district that St Patrick's Church was built. The architects were Weightman, Hadfield and Goldie of Sheffield who produced a restrained Gothic design with a pencil-thin spire. The presbytery, on the other hand, shows a decidedly French influence in the shaping of its mitre roof and the lucarne-like dormer windows. It also possesses a dramatic oriel window that over-sails the entrance to form a porch. The foundation stone was laid on 17 March 1852 – St Patrick's Day, when else!

St Patrick's Church.

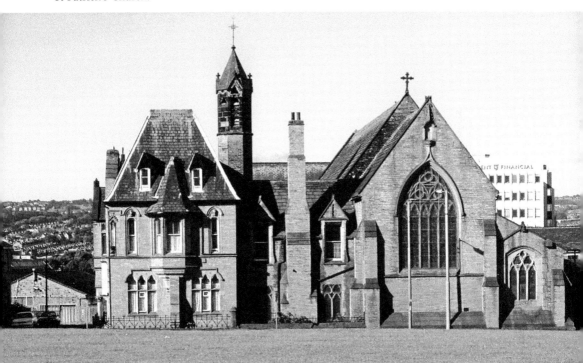

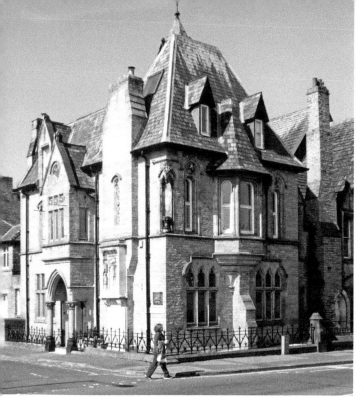

St Patrick's Presbytery.

38. Jamiyat Tabligh-ul-Islam Central Mosque, Westgate

Founded in the 1980s, the Jamiyat Tabligh-ul-Islam Central Mosque is among the largest in Britain, with a capacity of over 5,000 worshippers. It has taken some years to complete and the reasons for such a long campaign of building have been explained in relation to the

Jamiyat Tabligh-ul-Islam Central Mosque.

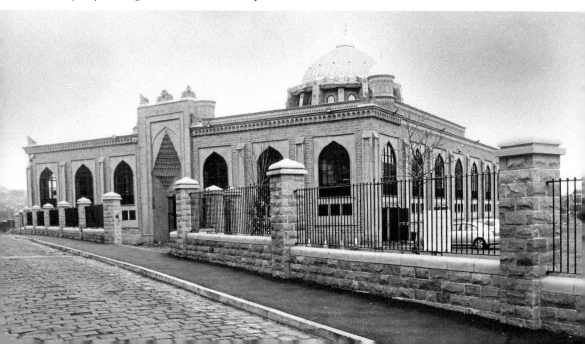

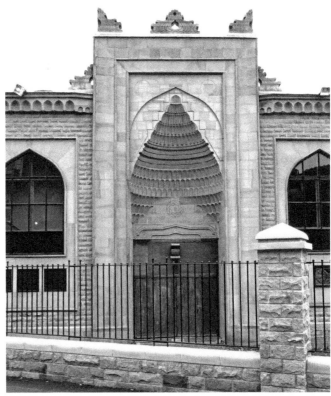

Right: Jamiyat
Tabligh-ul-Islam Central
Mosque entrance.

Below: Jamiyat
Tabligh-ul-Islam Central
Mosque dome.

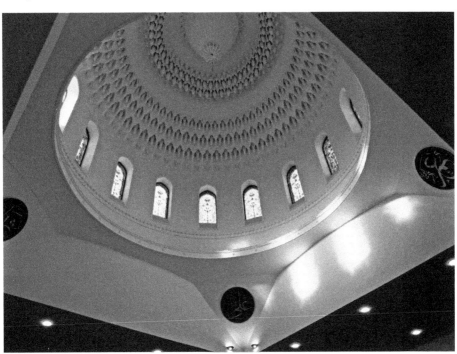

Suffa-tul-Islam mosque (*see* page 20). The design here is inspired by Mughal architecture and the main entrance is strongly influenced by Middle Eastern traditions of building. It is in the form of an iwan, a sort of entrance block that frames the pishtaq, or entrance gateway. The gateway itself has a vaulted inner ceiling, which is formed by honeycomb vaulting or muqarnas. This detailing can also be found in the dome above the prayer hall where the top lighting creating a numinous interior.

This is an outstanding mosque, which overlooks both Westgate and Drewton Street, arterial routes through Bradford. Its presence is imposing and, like a number of purpose-built mosques, it has added to the richness of the city's architectural heritage.

39. The Yorkshire Penny Bank, North Parade/Manor Row

As ideas about social reform evolved in the nineteenth century, notions of sobriety, modesty and thrift became key components in an ethic rooted in respectability, which, it was argued, might lead to harmonious relations between the classes and a society at ease with itself. But how to promote thrift? For much of the century banking was concerned with commerce and industry, not with small savers. In 1859, the manufacturer Edward Akroyd of Halifax and other of his associates established a bank for just such small savers, the West Riding

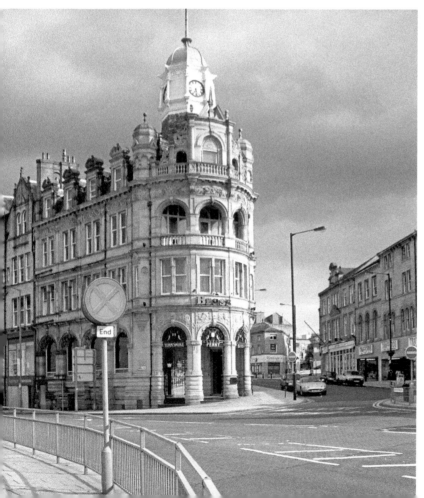

Yorkshire Penny Bank.

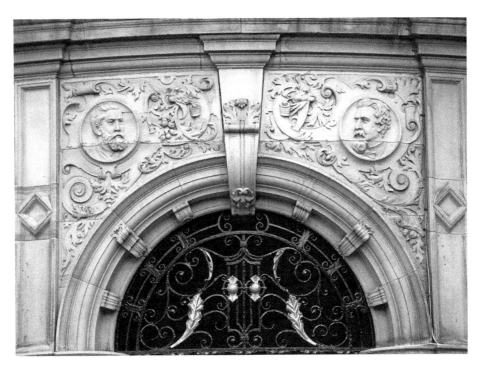

Reliefs above the entrance.

Savings Bank, which was a non-profit-making company. So successful was it that, in 1872, it was extended and branches planned across Yorkshire, its name now being changed to the Yorkshire Penny Bank.

The Bradford branch was rebuilt in 1895 to the designs of James Ledingham, one of a younger generation of architects in Bradford who succeeded the generation that had built the mid-Victorian town. Ledingham designed in a northern Renaissance style, as discussed above in relation to the Midland Hotel, but employing a rumbustious range of detail, and including relief panels of decoration that incorporated the profiles of its founders

The building no longer operates as a bank, and has undergone a number of different uses, yet it remains, perhaps, one of Bradford's best-known buildings being situated at the northern 'gateway' to the city centre, and terminating the view towards the city from along Manningham Lane.

4c. Warehousing, Manor Row

Little Germany (above) was developed with textile warehouses between approximately 1850 and 1870. However, the need for further warehousing continued after these dates. Proximity to the two Bradford railheads was of some importance, since this reduced transport costs and time in transit, but much of the space between the two was already crowded by 1870. Further developments continued along Sunbridge Road towards a new goods yard that had been opened in the 1870s at City Road, but there was also building in streets adjoining the railheads where land could be acquired.

Above: Warehousing, Manor Row.

Below: Date of construction.

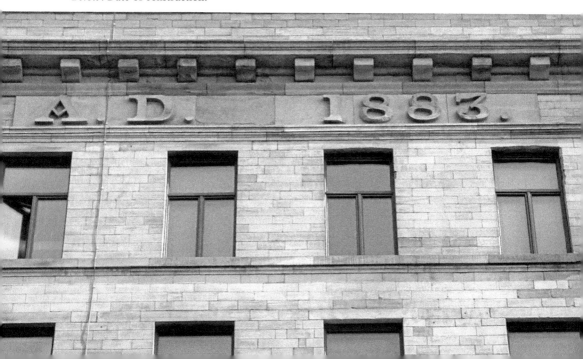

The warehouse illustrated is an example of the latter. Located in Manor Row, it was constructed in 1883 for merchants trading in wool and yarns by the architect Rhodes Calvert. Unlike much of the design of his contemporaries, Calvert worked in an austere but muscular classical style. In the warehouse above, apart from a heavy cornice, the upper storeys are unadorned, the first and second floors have severe pediments, while the ground floor supporting this bulk of stone sits on squat piers with overscaled pediments and detail, as if straining at the weight. In keeping with such strength is the way the date of erection is cast in bold relief below the cornice. Calvert is a little-known architect, few of whose commissions appear to have survived or come to light, but those that do show an individual approach that runs contrary to architectural trends of the later nineteenth century.

41. Bradford Reform Synagogue, Bowland Street

St Patrick's Church, the Jamiyat Tabligh-ul-Islam Central Mosque and the Bradford Reform Synagogue are within a short walk of one another, markers of the migrants who have come to Bradford in the past 180 years and made the city their home. German Jewish families began to arrive in Bradford in small numbers in the 1820s and 1830s. They came to industrial cities across England to conduct business – to Bradford for the textile trade. Numbers of families continued to rise throughout the century, but remained relatively small

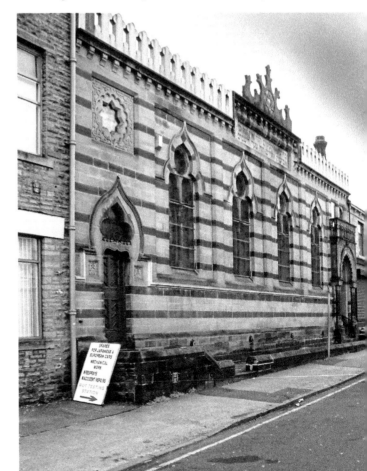

Bradford Reform Synagogue.

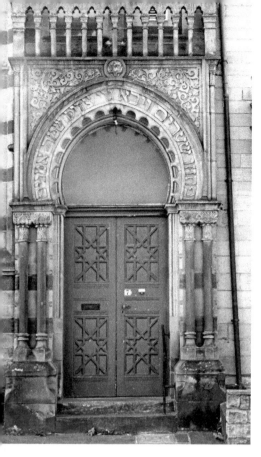

Reform Synagogue doorway.

and according to an article in the *Jewish Chronicle* of August 1865, religious observance in Bradford had fallen as families assimilated with the native population. It was not until the formation of the Jewish Association in 1873 that a new impetus was given to education and worship.

The Bradford Reform Synagogue in Bowland Street was built in 1880 to the designs of Francis Healey. He produced a frontage that was described at the time as 'Saracenic', a usual description of architecture that had details derived from Middle Eastern sources, such influence being untypical of mainstream trends. Built of buff sandstone with bandings of red sandstone, four traceried windows light the interior and, with their pointed horseshoe arches, match the doorway. Notice also how the tracery panels of the doorway form six-pointed arches.

The building remains a synagogue today, although with a dwindling congregation. It is also encouraging to note that in 2013 the synagogue underwent a programme of repair with help from local Muslim residents, an outstanding example of interfaith co-operation.

42. Belle Vue School, Manningham Lane

Bradford's central role in the creation of school boards and its subsequent pioneering of higher grade education has been referred to above (Feversham Street School). Belle Vue School is a good example of the attention that the Bradford School Board was willing to pay to higher grade schooling. The original school – Belle Vue Higher Grade Boys' and

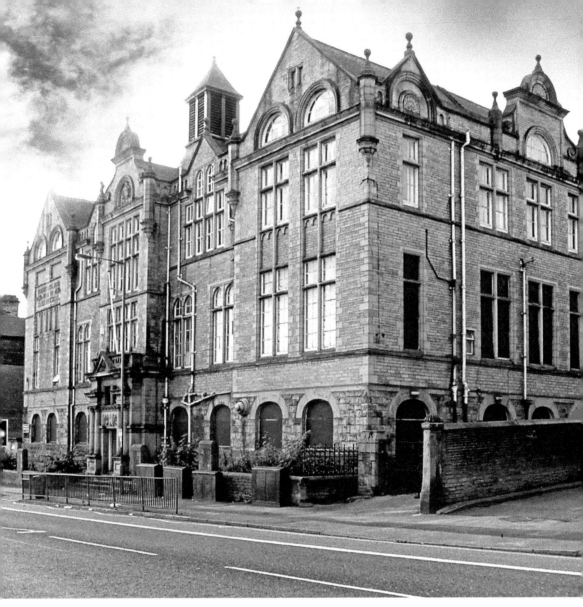

Belle Vue School.

Girls' Schools – was opened in 1879 by no less a figure than W. E. Forster himself. It was, however, expanded and rebuilt in 1895. It catered for a number of subjects that one would not readily associate with public education of the nineteenth century, for the subjects taught to all children were not only the three Rs, but also English, History, Geography, French, Art, Chemistry, Mathematics and Physics.

At Belle Vue, all of this was contained in a grand, even lavish, building designed by the architects Hargreaves and Bailey. They produced a Northern Renaissance design with an elaborate door frame that proclaimed the date of its erection, above which the school rose to three storeys terminating in an attic of shaped and pedimented gables. A characteristic of this style, employed here, is the use of lettering on the façades, and we are left in no doubt of the function from a panel above the first floor.

Belle Vue School door frame.

Inscription on front.

43. Tawakkulia Jamia Masjid, Cornwall Road

When the first Muslim migrants from South Asia arrived in the city in the 1950s and 1960s, their numbers were small, they were mostly male and had left their families behind. A room set aside in a house or a terraced house converted to a mosque was sufficient for worship. But as numbers and confidence grew, and as families settled here, the purpose-built mosque came into being.

This was the origin of the Tawwakulia Jamia Masjid – the Tawakkulia Communtiy Mosque. In 1969, the Tawakkulia Islamic Society began a house mosque at No. 40 Cornwall

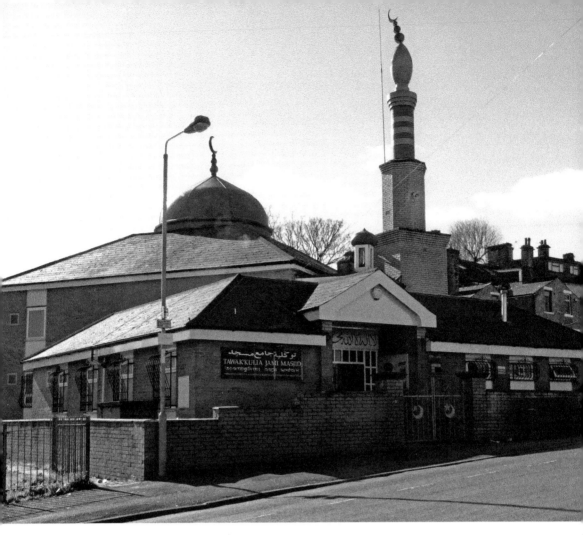

Above: Tawakkulia Jamia Masjid, Cornwall Road.

Right: Tawakkulia Jamia Masjid, entrance.

Road, expanding later to take in No. 42. But by the 1970s it became clear that a community mosque was needed. As land adjacent to these properties became available it was bought and became the site of a new mosque, the first purpose-built mosque in Bradford. As with later mosques, building took place over a number of years as funding became available. Firstly a single-storey building was erected to provide space for prayers. This was followed in the 1980s by a second storey, and lastly by the addition of a dome and minaret. Although a relatively simple building when compared with some of the other mosques illustrated, the head to the entrance doorway to the mosque is decorated with calligraphy.

It stands in an area of housing just off the A650, Manningham Lane, one of the main highways into the city. In some ways, especially in the materials chosen, the mosque seems at odds with its surroundings. Yet this is what is so distinctive about Bradford – turn the corner of a street full of humdrum houses and commercial premises and be surprised by the expression of the city's diverse cultures.

44. Bolton Royd House, Manningham Lane

At the beginning of the nineteenth century the out-township of Manningham remained a small village with fields that separated it from the town of Bradford (what we would

Bolton Royd House.

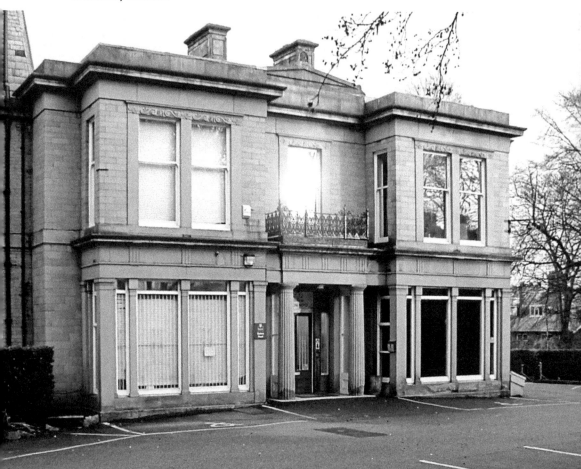

today recognise as the centre of the city). Here lay its prime asset: land for building, and Manningham was to be developed as the premier middle-class suburb of the city.

One of the first of these developments was Bolton Royd House, built for J. G. Horsfall around 1832. Horsfall was a worsted spinner and manufacturer. His mill stood behind the parish church, and he had provoked rioting in this part of the town when he attempted to introduce steam-powered looms into his mill in the 1820s. His house is designed in a Greek Revival style with a Doric portico to the entrance and typically Greek anthemion (honeysuckle) carving to the window heads. This house is also notable in heralding the beginning of the Manningham suburb, for although Horsfall's mill was in town, as the *Bradford Illustrated Weekly Telegraph* was to put it in 1885, the house when first built might 'offer a great charm to a gentleman wearied during the day with the incessant clack of the loom', yet lay 'within a convenient distance from his business'.

45. Mount Royd, Parkfield Road

Bolton Royd House had stood in several acres of landscaped grounds in the 1830s and 1840s. After the death in the 1850s of J. G. Horsfall, the manufacturer who owned the Bolton Royd estate, his executors sold much of the grounds for building land and specifically for the building of villa residences. The villas at Mount Royd were erected on the former estate in 1863 to the designs of Lockwood & Mawson. The commission came

Below left: Mount Royd, Parkfield Road.

Below right: Mount Royd: The Hollow.

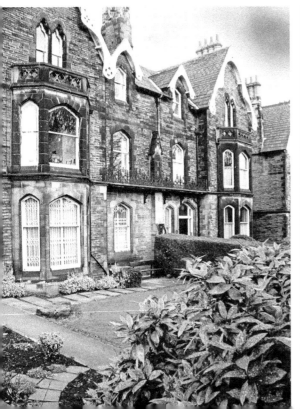

from the Mount Royd Building Club, a group of wealthy merchants and professionals – one family, for instance, were the Wolffs, German merchants who had settled in Bradford, and whose son Humbert became a popular poet in the 1920s and 1930s.

Lockwood & Mawson laid out four blocks of semi-detached houses alternating between simple Gothic and Italianate styles. In addition there was a communal garden to the fronts consisting of two lawned areas with walks and shrubberies, and known as the Hollow. Mount Royd is typical of the organisation of space in the Victorian suburb: the houses are spacious and have a rural feel, yet have three-storeyed urban form; there is a shared garden area; the access road is private and gated. Much of Manningham was developed in this way.

46. Cartwright Hall Art Gallery, Lister Park, Manningham

The textile magnate Samuel Cunlife Lister had sold his Manningham Hall estate to Bradford Corporation in the 1870s for £40,000, the grounds of which were eventually to become a public park. Lister's ideas went further than this, however. What he wanted, in addition, was a museum of technology named after Edmund Cartwright, one of the first to apply power to the loom and experiment with a power wool comb. This idea coincided with much debate in late nineteenth-century Bradford about the lack of a municipal gallery. In the end the argument came down in favour of an art gallery and public rooms located in the park, but in deference to Lister this was to be named the Cartwright Memorial Hall.

The design was an important one, set in a commanding position above one of the principal highways in the city. As such, it was put out to competition, the winner being

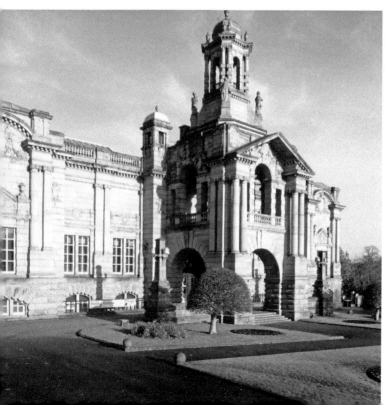

Cartwright Hall Art Gallery.

the London-based architectural practice, Simpson and Allen. What they provided was a massive baroque design with an entrance via a gigantic port cochère, above which is an ornate confection of broken-floor pediment and arches, the whole crowned with a cupola, which is a complex of columns and statuary – a Vanburgh-like composition. The gallery was opened by Lister himself in April 1904, who was said by *The Times* to have contributed £47,000 towards the building of the gallery.

In 1897, Bradford had been awarded city status and the gallery was perhaps a marker of this. It was also a continuing example of the civic pride that had inspired the mid-Victorian town whose corporation were intent on providing places of respectable entertainment, which might also be morally uplifting. Perhaps in the same spirit the park setting of the gallery has been sympathetically remodelled in recent years. In 2001, a Mughal garden with formal layout, water and fountains, was created, the first of its kind in the north, and which Bradford Council has described as, 'a synthesis between Islamic and Indian architectural styles'.

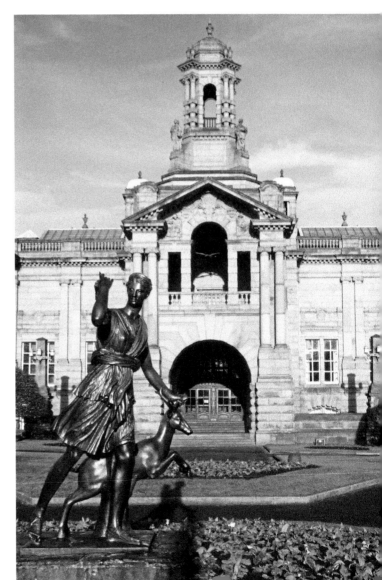

Cartwright Hall Art Gallery, entrance.

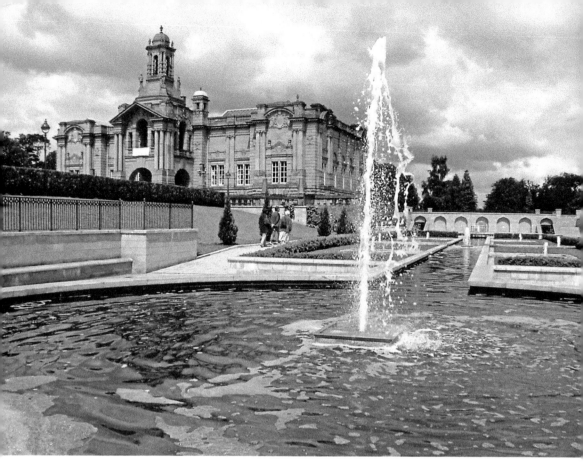

The Mughal Gardens at Cartwright Hall.

47. Manningham Mills, Heaton Road

There has been a mill on the site of Manningham Mills since 1838. However, the story of how the mill arrived at its present form, how it is tied up with the success of Bradford's nineteenth-century textile industry but at the same time is atypical, is a complex one. It is also deeply rooted in the textile fortunes of the Cunliffe-Lister family, especially Samuel Cunliffe-Lister.

The Cunliffes of Addingham had been in textile production since before 1800. Ellis Cunliffe had married Ruth Myers, a niece of Samuel Lister, and from a landed family of Manningham Hall in Bradford. After a series of deaths in the Lister family, Ellis became the owner in his wife's right in 1819 when he added the name Lister to his own. He went to live at Manningham Hall and in 1838 was to build Manningham Mill, a worsted spinning mill. The business was to be continued by his sons, but on a different scale and in different directions. Instrumental to the success was Samuel Cunliffe-Lister, who is said to have made three fortunes. A man of inventive genius, he had been able to introduce the first practicable machine wool comb; he went on to invent a process for producing silk thread from silk waste; and he was able to apply innovations in textile machinery to the production of velvets and upholstery materials.

After a fire in 1871, the old Manningham Mill was rebuilt and extended between that date and the 1880s, the architects being the Bradford practices of Andrews and Pepper,

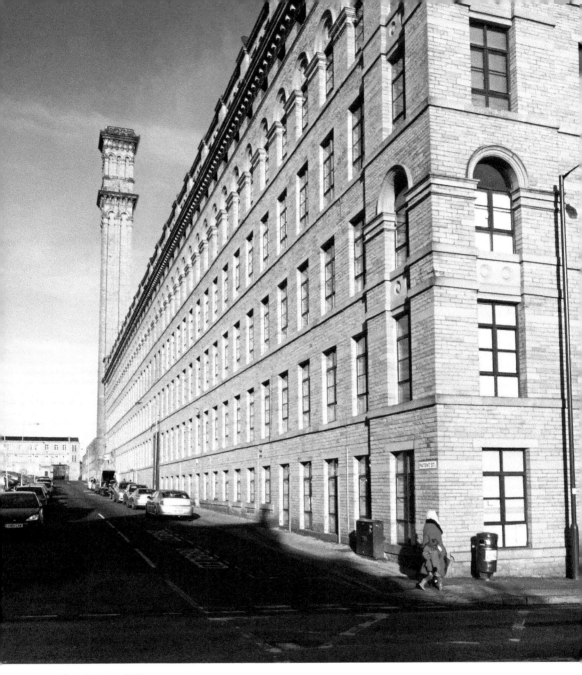

Manningham Mills.

and later James Ledingham. It became the largest silk spinning and manufacturing mill in Britain, producing silks, plushes and velvets, and employing 5,000 people. It stands high up in Manningham, dominating the skyline like a hill-side palace above its dependencies. Italianate in style, it is one of the most architecturally embellished industrial buildings in the Bradford district. The entrance makes a bold statement with the arms of its builder fixed above the gateway. But the most remarkable feature of this mill complex is the chimney. This massive construction is 249 feet high, its sides panelled, an elaborate

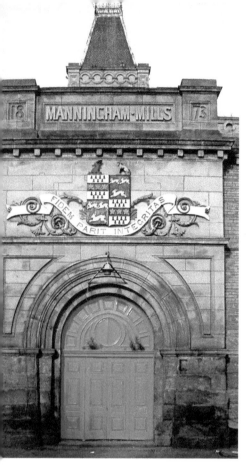

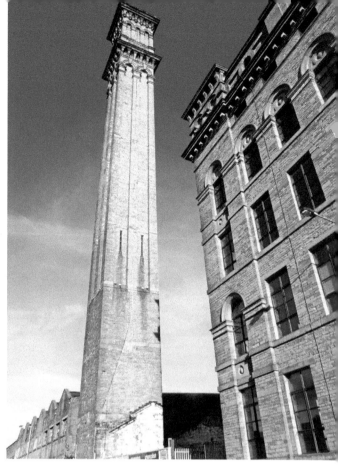

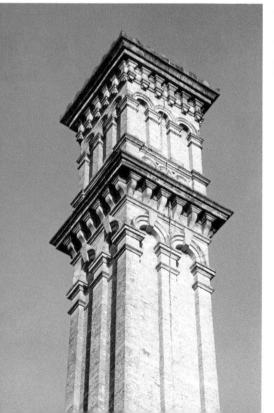

Above left: Manningham Mills' entrance.

Above right: Manningham Mills' chimney.

Left: Chimney termination.

cornice and arches making up the termination. This whole composition probably drew on the campanile of San Marco, in Venice for its inspiration. On its completion in November, 1873, the *Bradford Observer* reported of the chimney:

> Shortly before twelve o'clock, Mr Lister accompanied by Captain Lepper [the mill manager] the architects, Messrs Andrews and Pepper, and Mr William Beanland, the builder, ascended. The summit having been reached, the baptismal right was performed by Mr Lister breaking a bottle of wine and naming the column 'The Lister's Pride'. The party then partook of a champagne luncheon.

During the 1980s the mill declined, and in the 1990s lay derelict for a number of years until it was eventually restored and converted to apartments early this century.

48. Saltaire Mills, Saltaire

Titus Salt was the creator of Saltaire, the model (i.e. exemplary) industrial village on the outskirts of Bradford by the River Aire – hence the name: 'Salt' and 'Aire'. Historians disagree about his motives some attributing Saltaire to philanthropy, while more left-wing interpretations have emphasised control over the workforce in providing housing tied to work. Neither explanation can be fully accepted, yet neither is fully wrong. Salt was a manufacturer, who had introduced alpaca hair into the production of worsted to create what became a fashion fabric through the middle years of the nineteenth century and until the 1870s. By 1850 he had already made his fortune in a number of mills in Bradford, where philanthropy did not seem to have modified his manufacturing, but where he would have understood the importance of the provision of houses for the textile workforce, a common practice among some manufacturers. That he went on to do the same is, thus, in some respects unsurprising. The difference is more in what Salt's intentions were. His mayoral year in Bradford in 1848, was a year of rioting and serious trade dislocations. It seems probable that Salt had considered the arguments of social reformers who stressed that decent housing and fair treatment by employers towards labour were key elements of a harmonious society. In this sense, Saltaire *was* philanthropic and *was* controlling, yet it was neither soft-hearted nor ruthless, but sought to establish an ideal society.

The mill came first and was completed in 1853. It was said by contemporaries that Salt and his architect Henry Francis Lockwood, had considered buying the Crystal Palace once the Great Exhibition had closed, but rejected it as unsuitable. Instead Salt commissioned the newly established firm of Lockwood & Mawson together with the engineer William Fairburn to design the mill. They produced a huge industrial complex on one side of the Leeds and Liverpool Canal where raw materials could be taken in, sorted, scoured, combed, spun, woven; and where finished goods could be packed and dispatched by the railway that ran along the other side of the mill. All was embellished with Italianate decoration, from the two massive arched windows either side the entrance into the mill and engine house, to the campanile-like arches above the staircase towers, or the heavy eaves cornice. In 1868, capacity was extended by the erection of a further mill, New Mill, to the north and located between the canal and the

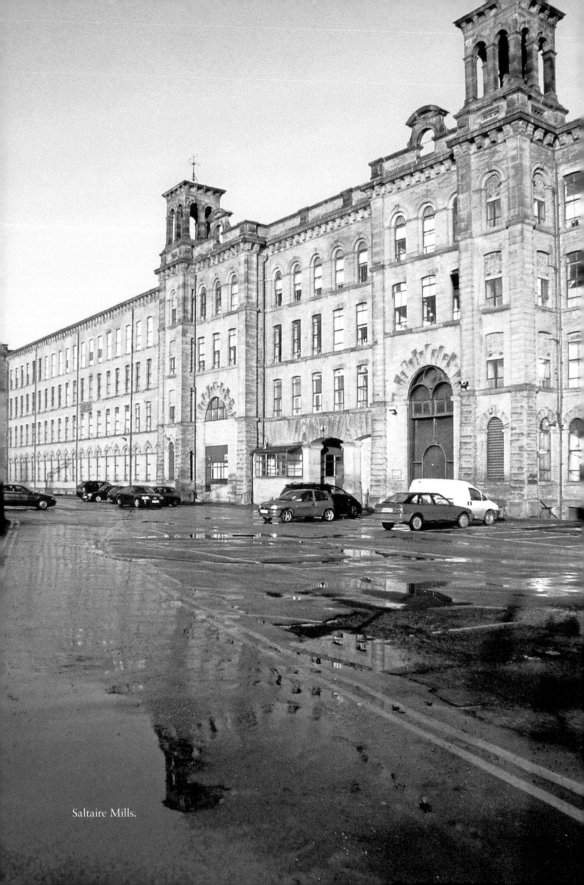

Saltaire Mills.

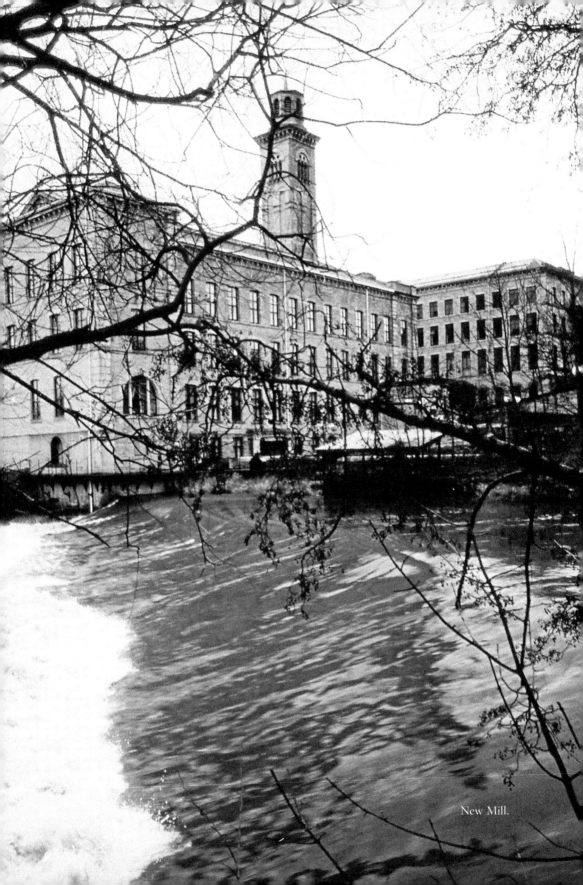

New Mill.

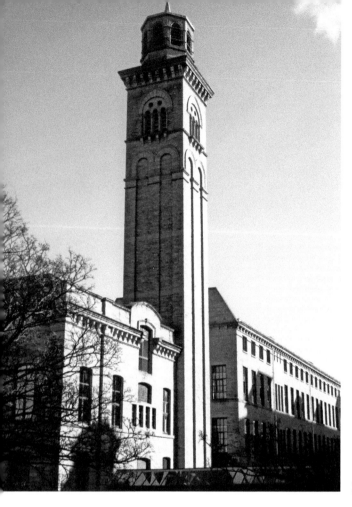

New Mill chimney.

River Aire. This is a plain building, but for its chimney, which seems to draw its inspiration from the campanile of the church of Santa Maria Gloriosa dei Frari in Venice.

Saltaire Mills was not the first large textile mill, but its scale and design undoubtedly began a trend in Bradford towards more prestigious industrial buildings. Manningham Mills (above) is perhaps both its heir and rival.

Textile production ceased in the 1980s, and the mill now holds a collection and permanent exhibition of David Hockney's work at the 1853 Gallery.

49. George Street, Saltaire

As the mill came to completion, houses were being planned and built. There was eventually accommodation for around 4,500 people, although not everyone worked at Salt's mill. A range of housing was built, from small terraced cottages to villas intended for the managerial staff of the mill. Much of this housing is enlivened with Lockwood & Mawson's Italianate detailing, but not all. It is said that Salt's architects conducted a survey among his workforce to assess what sort of accommodation they required. No evidence of this has come to light, but, if true, then the majority did not seems to have had very high expectations, since the core houses of the village are plain two-ups, two-downs built of

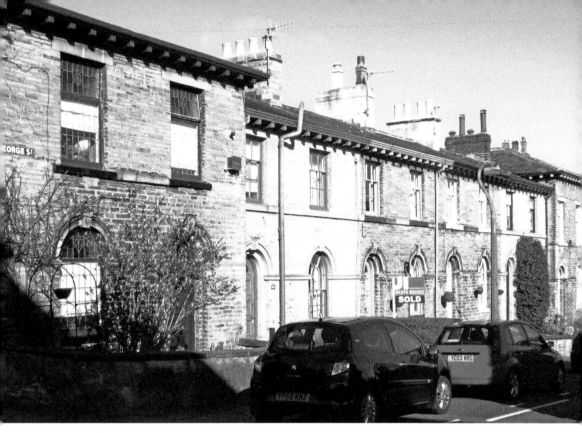

George Street, Saltaire.

courses of Shipley rock – a soft sandstone quarried locally – with entrance directly from the street into the living room. However, cottages that terminate the rows or occupy main routes through the village tend to have been given a more attractive treatment; for example, in George Street the detailing may be modest, but it lifts the whole tone of the street.

The advantages that Saltaire had over other industrial settlements far outweighed arguments that arose in the late nineteenth and twentieth centuries about design and density of housing. Firstly, Saltaire was removed from the polluted atmosphere of a place like Bradford; secondly, every house had its own lavatory, pure water supply and open passageway at the rear for the removal of refuse. Not many working-class families could say that in the Bradford of the 1860s.

50. The Congregational Church, Saltaire

What Salt probably intended to establish at Saltaire was a respectable community where education, hard work and sobriety were to be valued. To that end, schools, a public hall for instructive public meetings and entertainment and a public park were added. There were no public houses, and sale of alcohol was frowned upon. Moral probity was a further value, and religion had a part to play here. Salt himself was a Congregationalist, and the Congregationalist Church was another of Lockwood & Mawson's commissions. They produced a baroque design that was carried out between 1856 and 1859, with a principal emphasis placed on the entrance opposite to the mill.

This has a semicircular porch supported on Corinthian columns with a bell tower rising above, its dome supported on similar columns. As John Ayers has commented in *Titus of Salts* (Watmough, 1976), the fine detailing of the chapel and its positioning 'contrasts beautifully with the heavier masses of the mill alongside'. While Salt was a Congregationalist the central point was the practice of a Christian religion, hence other religions were allowed to build – the Wesleyan Methodists erected a chapel in Saltaire in 1866 and the Church of England already possessed St Paul's Church about fifteen minutes' walk from the village.

When Salt died in 1876 he was buried in the mausoleum next to the church. By this date, his vision had been completed: a decent place in which to work and live with facilities that provided respectable and rational recreation, if under the watchful eye of its owner. But what price such paternalism? As Ruskin commented about model industrial villages in general at his lecture in Bradford in 1864 (above, Wool Exchange), the heart of such a village was the mill, and:

> In this mill are to be in constant employment from eight hundred to a thousand workers, who never drink, never strike, always go to church on Sunday, and always express themselves in respectful language.

'Traffic' in *The Crown of Wild Olive* (1866)

Congregational Church.

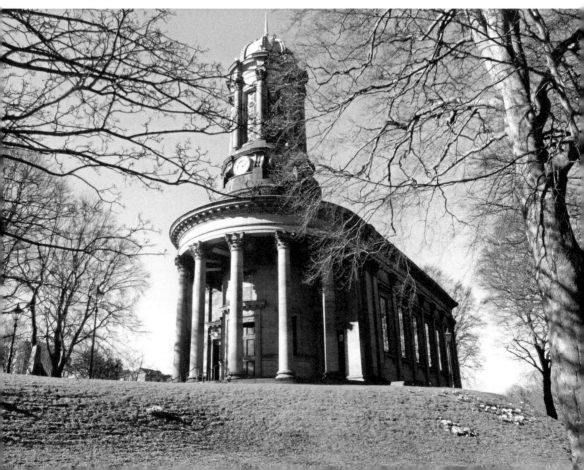

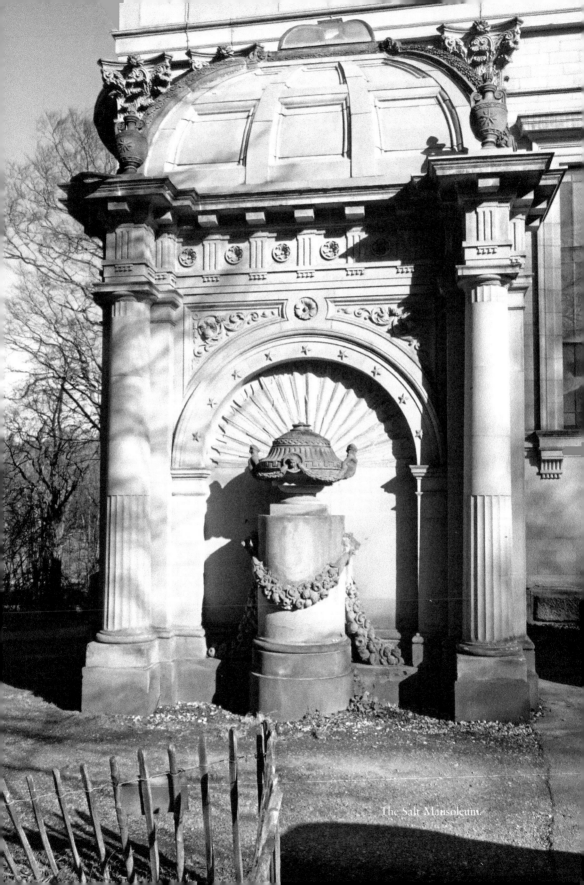

The Salt Mausoleum.

Further Reading

Ayres, John, *Architecture in Bradford* (Watmoughs Ltd, 1973).

James, David, *Bradford* (Ryburn Publishing, 1990).

Linstrum, Derek, *West Yorkshire Architects and Architecture* (Lund Humphries Publishers Ltd, 1978).

Reynolds, Jack, *The Great Paternalist: Titus Salt & the Growth of Nineteenth-Century Bradford* (Maurice Temple Smith, 1983).

Roberts, John, *Little Germany,* Bradford Art Galleries and Museums, 1977.

Sheeran, George, *Brass Castles: West Yorkshire New Rich and their Houses, 1800–1914* (Tempus, 2006).

Acknowledgements

The text and the images are the author's. They would have been wanting, however, but for the comments of Dr Paul Jennings and Yanina Sheeran, both of whom I wish to thank.